The Inspiring Life

OF TEXAN

HÉCTOR P. GARCÍA

The Inspiring Life

OF TEXAN

HÉCTOR P. GARCÍA

CECILIA GARCÍA AKERS

THE
History
PRESS

Published by The History Press
Charleston, SC
www.historypress.net

First published 2016

Manufactured in the United States

ISBN 978.1.46711.901.6

Library of Congress Control Number: 2015957669

This book is dedicated to my loving husband, Jimmy Akers, who agreed to accompany me on this wonderful journey to honor my father.

And to my parents, Dr. Héctor P. and Wanda F. García. I am eternally grateful for the love and guidance they gave me in order to live my life with dignity and courage.

CONTENTS

CONTENTS

FOREWORD

D r. Héctor P. García's half century of Hispanic civil rights activism has been well documented over the past three decades. Yet little is known of his private life. This short book, written by his daughter, Cecilia García Akers, helps to fill that void. It gives us intimate insights into the private joys and sorrows, triumphs and tragedies of this great man, his wife and their children. Of equal importance, it sheds light on the little-known heroic support that Dr. García's wife and children continually gave to provide him the time and the material resources he needed to achieve his remarkable accomplishments in the causes of civil rights and social justice in Texas and across the nation.

Dr. García led a very full life. The author of this work describes his daily activities serving patients, family and local, state and national communities. This man's commitment to others, his perseverance, his courage and his boundless energy are legendary to those of us who knew him. Cecilia García Akers provides numerous examples of these virtues and demonstrates his unrequited love for his family. In my association with her father, I glimpsed some of these characteristics firsthand. The anecdotes that follow illustrate this point.

While writing a book on the Felix Longoria controversy of 1949, I had occasion to spend a good deal of time taping interviews with Dr. García, who was one of the principal actors in shaping this historical event. His actions in the Longoria affair launched him and his newly founded American GI Forum veterans' organization into the national forefront of the growing

Hispanic civil rights movement. In addition to his interviews with me, Dr. García also arranged my meetings with a number of other individuals who played various roles in this particular civil rights drama. Some of these encounters took place at regional and national meetings of the GI Forum.

On May 5, 1990, he and I drove to a Houston GI Forum state convention, where I would interview Felix Longoria's widow, Beatrice Moreno de Longoria. We left his office at around 2:00 p.m., after he had already completed six nonstop hours preparing for and attending to appointments with patients. He then drove us the more than two hundred miles between Corpus Christi and Houston in his tired old Cadillac, a car he and the previous owner had driven many miles. Dr. Héctor occasionally purchased a new car. He made less money than most MDs because many of his patients could not afford to pay for his services. I visited his office to interview him dozens of times over the ten-year period I spent researching the Longoria book. Not once did I see money exchanged between patients and the doctor's staff. Invariably, the conversations I heard stated a lack of both medical insurance and money to pay for visits, as well as a promise to pay whatever the patient could at some later date. No matter, he saw them anyway. Serving the sick and the needy seemed more important to Dr. García than earning enough money to buy a new car.[1]

We arrived in Houston at the meeting place at around 5:30 p.m., just in time for the opening ceremonies. A formal meeting between Forum state officers and chapter delegates commenced shortly. It lasted approximately two hours, covering topics ranging from the local concerns of specific chapters to general matters related to veterans' affairs and Hispanics civil rights. After the business meeting came the reception dinner, during which Dr. García gave the convention's keynote address on deplorable living conditions in the Hispanic *colonias* of the Rio Grande Valley. He closed by admonishing the Forum to push for local, state and federal government intervention to remedy the problems. Dr. Héctor was not able to enjoy much of his dinner because of his speech. I, on the other hand, remained seated at the founder's table and ate my full meal. More importantly, while Dr. García spoke, I was seated between two of the most important figures in the Longoria controversy: Felix's widow, Beatrice Moreno de Longoria, and their daughter, Adela Longoria de Cerra.

The reception and the convention finally ended around 10:00 p.m. After a half hour of Dr. Héctor saying goodbye to many friends, and my arranging for the first of many interview taping secessions with Felix Longoria's widow and daughter, the doctor and I began the drive back to Corpus Christi. We

pulled up to his office on Bright Street at 2:00 a.m. I started to get out of his car while thanking him for inviting me to the Forum convention and arranging my meeting with Beatrice and Adela. He said, "Wait. We are not done yet." He handed me a lab coat with a name tag on it that read, "Dr. Patrick Carroll, Special Assistant to the Founder." Driving again, he informed me that I was accompanying him on his 2:00 a.m. rounds at Memorial Hospital. He said that I "might learn something from the experience." We had finished seeing his in-patients by 4:00 a.m. I still have the pin, but he took the lab coat.

On the way back to his office, my car and hopefully some sleep, I pointed out that he had just finished a twenty-hour workday between his medical duties and his civil rights activities. Did he normally put in such long days? He laughed and assured me that he did not—on weekdays, he only worked about eighteen hours and just eight- to ten-hour days on weekends. He explained that Saturdays and Sundays were family days, when he slept as many as five hours per night and spent six to eight of his waking hours with his wife and daughters. This weekly schedule, divided between his medical practice, civil rights activities and his family—which, as mentioned earlier, Dr. García rigorously maintained for fifty years—underscores an often unrecognized aspect of the lives of great individuals devoted to public service. The time they allot to community service usually far outweighs the time they spend with their families. Dr. Héctor proved no exception to this rule. An incident described to me independently by both the doctor and his wife, Wanda Fusillo García, emphasizes this point.

In 1970, Hurricane Celia struck Corpus Christi. At the time, Dr. García was out of town on GI Forum business. As soon as he heard of the hurricane's landfall, he rushed home. Bursting into his home early the morning after the storm had struck, he found his wife and three daughters huddled in the hallway of the bedroom wing of their house sitting in six to eight inches of water. He asked if they were all right. When they replied yes, he told them he had to leave immediately for his office to attend to the medical needs of the residents of the city's west side Hispanic barrio. This event not only reflects the aforementioned rule, but it also demonstrates the heroic sacrifices and struggles that families privately endured in order to provide remarkable champions of the people, like Dr. García, the public space to accomplish so much in the advancement of civil rights.

These two anecdotes illustrate many of Dr. Héctor's virtuous character traits witnessed by virtually all of us who knew him—his record of ongoing commitment to others as well as his perseverance in the struggles for civil

FOREWORD

rights and social justice. Cecilia García Akers's work provides a much more in-depth, lengthy and intimate profile of this great man. It documents, through its photos and commentary, the challenging but rewarding private lives of a storied Hispanic civil rights leader and those closest to him—their personal triumphs and tragedies, joys and struggles. Enjoy the read.

DR. PATRICK J. CARROLL
Professor of History, TAMUCC, Retired
Corpus Christi, Texas, September 10, 2015

ACKNOWLEDGEMENTS

Writing my very first book, *The Inspiring Life of Texan Héctor P. García*, has been a very rewarding experience. I am honored that I was given the opportunity to write this unique book about my father, as I was able to learn more about several major events in his life.

The success of this book is attributed to many people. First, of course, my husband, Jimmy, who managed all the photos and typed the manuscript.

Grace Charles, the "keeper" of my father's papers at Texas A&M University–Corpus Christi, e-mailed, mailed and scanned many documents and photos for me, at times without much notice. I was able to research the many topics of this book due to Grace's help. She is an invaluable resource at Texas A&M University–Corpus Christi.

I appreciate the kindness that Dr. Pat Carroll has always had for me and my father. The words in the foreword of this book reminded me of how fortunate we were to learn from this astonishing man and have him in our lives.

Dr. Rebecca Saavedra's timely contribution of the introduction reflects a true example of one who has worked tirelessly in her profession but took the initiative to learn about Dr. Héctor García and his influence in education, healthcare and civil rights. Dr. Saavedra is truly grateful for my father's past advocacy for her to achieve the success she has in her own life.

My cousin Tony Canales offered much insight into my father in the years before I was born. Tony spent many years with my father as he was organizing the American GI Forum. They were very close until my father passed away in 1996.

ACKNOWLEDGEMENTS

I want to thank my sister Susie García for her advice, patience and words of encouragement for me in completing my first book.

My cousin Massimo Fusillo assisted me with the Italian grammar and in interpreting my mother Wanda's doctoral thesis.

Special thanks to my publisher, The History Press, for its professionalism and sincere interest in my work. My editors have given me a unique opportunity to expand my skills and develop a talent in something I never imagined I would ever do.

And thanks to all my friends on social media who responded, supported and liked all my posts and photographs regarding my book. I hope you all find my book worthy of allowing us into your lives.

INTRODUCTION

Any book about Dr. Héctor García should be in everyone's personal library. Forgive me, but that is how important I believe his achievements to be. And a book written by his middle daughter, who lived through the tough times with him and who saw on a daily basis what his compassion and commitment really meant? Well, that is a perspective that is so unique and personal that it must be read by all those who are proud to be Americans.

This is a heartfelt story about a man who didn't wait for change to happen; it is a personal remembrance about a man who actually changed the world we live in for the good. I often think of what the world would be like without Dr. Héctor. What if he had not been there to speak up for veterans, patients, widows and mothers? What if he had not typed those hundreds of letters in the night to administrators and public officials, admonishing them about the conditions and segregation of schools, hospitals, neighborhoods and swimming pools?

These stories illustrate time and again the fortitude and strength he needed to pursue his righteous cause—and not just by him but by his family as well. I love the quote that Dr. Héctor was "a man who in the space of one week delivers twenty babies, twenty speeches and twenty thousand votes."

But those twenty babies, twenty speeches and twenty thousand votes took twenty-hour days and meant great sacrifices on his family's part. His wife and children felt the brunt of his compassion for the greater good, and his absence from their day-to-day lives took its toll. Many times his family was threatened and harassed because of his efforts. But like many great men, his

family rallied around him and gave him the strength to continue his fight against injustice. He could not be silenced.

Dr. Héctor was a graduate of the University of Texas Medical Branch (UTMB) at Galveston. His legacy is important to us who work here, and his connection is meaningful. He serves as a giant role model for all of us, but particularly for our Latino students. Here is a man who valued his culture, pursued his education against great odds and leveraged his position as a physician to advocate for education and civil rights and against racism and injustice.

His story remains timely and relevant. It is a successful immigrant story. He was proud of his parents and of his nationality. This was instilled in him from an early age. His parents were teachers, and he was proud to say that he was named after a Trojan hero and his brothers and sisters after Aztec leaders. He was neither the only success in his family nor the only doctor in his family; all told, there were six physicians among his brothers and sisters—a wonderful testament to the American immigrant story!

I am amazed at the scope of his work and influence even in the legal arena. There was the *Hernandez* case, which stopped the elimination of Mexican Americans from grand juries, and the *Delgado v. Bastrop Independent School District* case, which was the landmark Mexican American school desegregation case in Texas. His efforts helped end the Texas poll tax, which prevented poor Texans from voting. Every United States president from Kennedy to Clinton understood that he was the person to lobby and deliver the votes in South Texas. It is not a surprise that he was awarded the Presidential Medal of Freedom by President Reagan, only that it took so long for Dr. Héctor García to be recognized for his work.

Dr. Héctor believed in the promise of America and spent a lifetime ensuring that the Constitution protected every American no matter their race, ethnicity or economic status. His story is a great one, and it is important that we keep it alive and share this book widely with our children and grandchildren.

DR. REBECCA SAAVEDRA
Vice-President of Strategic Planning
University of Texas Medical Branch
Galveston, Texas

IMMIGRATION AND EDUCATION

Héctor Perez García was born in Llera, Tamaulipas, Mexico, on January 17, 1914, to Jose and Faustina García. He was their second child, following another son's birth, Jose Antonio. Two daughters, Emilia, and Clotilde, were also born in Llera, Mexico. They would leave Mexico in 1917, when Héctor was three years old. Jose and Faustina García were both educators in Mexico. They were embroiled in the Mexican Revolution and feared for their safety and that of their children. The violence had escalated, and the unknown factors as to who would triumph in the Revolution caused the García family to plan their exodus from Mexico. Having four young children to protect, they decided to move their family and their belongings to settle in Mercedes, Texas.[2]

Jose had family in Mercedes. He thought this would be the best transition for everyone. Unfortunately, their educational credentials did not transfer to Texas, and Jose and Faustina were unable to teach in the United States. Having to channel his energies elsewhere, he chose to teach all of his children at the highest education level possible. Settling in Mercedes, Texas, with several of Jose's bothers, they opened and operated a dry goods store named the Antonio G. García and Brothers Department Store.

Jose was an educator. Although he enjoyed the time with his family in the collaboration of the retail business, this was not why he had received an education. His struggles went beyond financial. His intelligence and desire to teach would always be with him.

The children would go to school during the day. Héctor would help in the store after school. However, young Héctor had his eyes on other activities such as sports. He loved baseball and spent as much free time as possible playing with his friends. Jose knew that discipline was the key. Apparently, young Héctor would have to be corralled with a belt to make him come home. Faustina, however, would have him spared from Jose's anger for the day.

Héctor, as I have been told, was probably the most difficult of all of Jose's children. The García family expanded to ten children, so the financial burdens really escalated. Jose's desire to educate all of the children responsibly would make things difficult.

Jose and Faustina had escaped the Mexican Revolution in 1917. However, they would experience a totally different world—one of segregated schools, a segregated city and struggles that occur when there are racist attitudes toward immigrants. Jose firmly believed that a proper education and

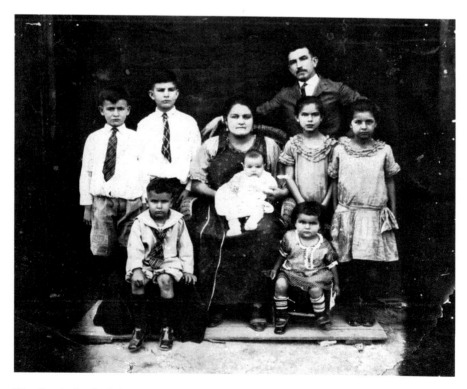

The García family. *Left to right, first row*: Héctor, Antonio, Faustina (with Cuitlahuac on her lap), Jose, Emilia and Clotilde. *Left to right, second row*: Cuauhtemoc and Dalia. *García Papers, Special Collections and Archives, Bell Library, Texas A&M University–Corpus Christi.*

independence would guarantee his children success in life. He was able to develop an educational tool, a book that taught vocabulary, reading and basic skills to assist his children in the educational process. Jose knew and understood the barriers that they would encounter.

The lessons with his children occurred nightly after all the chores were done. Jose would take his children into the basement of the store and teach them history, government, English and mathematics. All of his children were bilingual. The García children became very accomplished and successful. It was not a matter of who made the most money or who had the flashiest lifestyle. The children grew up to be dedicated professionals. J.A., Héctor, Clotilde, Cuitlahuac, Dalia and Xicotencatl all became medical doctors and had their own careers. Not only that, but they would also take care of thousands of patients, assist their communities and become involved in politics and the education of our youth. They would all give back to their communities and remain humble. Jose and Faustina taught their children well.

Héctor P. García would face discrimination and educational battles all his life. The first known encounter was when Héctor was in high school in Mercedes and his English teacher told him that no matter how hard he tried, "no Mexican would make an A in her class." As hard as Héctor tried, he still made a B. This was the first indication of what Héctor would endure all of his life to achieve the education he would need.

Héctor made it through school in Mercedes, Texas, and graduated from high school in 1932. He would hitchhike thirty miles daily to Pan American Junior College in Edinburg, Texas, for his basic college courses. Apparently, Jose García cashed in a life insurance policy to pay for Héctor's education. His family was determined to provide the best support they could. However, having a family with seven surviving children would be financially difficult for them.

Héctor went to the next level and graduated from the University of Texas–Austin with a bachelor's degree in zoology. He graduated in 1936 in the top 10 percent of his class. His degree in zoology was merely a steppingstone to the next level; it was a requirement. Héctor wanted to do well. He wanted his family to be proud of him and wanted to assist them monetarily. Most of all, he wanted his independence. He would never depend on anyone else for a job. The next level was in his sights. He was accepted into the University of Texas Medical Branch–Galveston in 1936. At the time, Galveston allowed for one Mexican per year to be accepted into its medical school. This was Héctor's year.

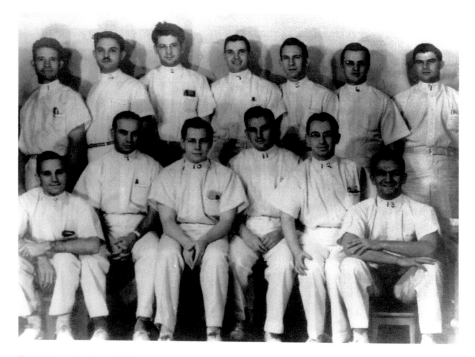

Dr. Héctor P. García (front row, lower right) with his fellow interns, completing their internship at St. Joseph's Hospital, Creighton University, Omaha, Nebraska, 1942. *Author's collection.*

He would make the best of it and become a medical doctor—the dream of his life and what he had worked toward had arrived. Graduating in 1940 from medical school, the difficult task of being accepted into a residency now faced him. Dr. Héctor had tremendous odds against him for acceptance. He applied in other states as well as his beloved Texas. No school would accept him. It was very frustrating to him that the state where he obtained his medical education and graduated would not grant him acceptance for his residency. I would ask my father, "How did you end up in Omaha, Nebraska?" As he explained, there was a group of physicians and recruiters from St. Joseph's Hospital in Omaha who sought out medical students for their resident program. They visited the University of Texas Medical Branch–Galveston and recruited Dr. Héctor and others for their medical and surgical training. Dr. Héctor was on his way to another level. He would state later that he really liked the team from Omaha. But the truth was that he could not obtain his medical and surgical residency in Texas or other states because of his ethnicity.

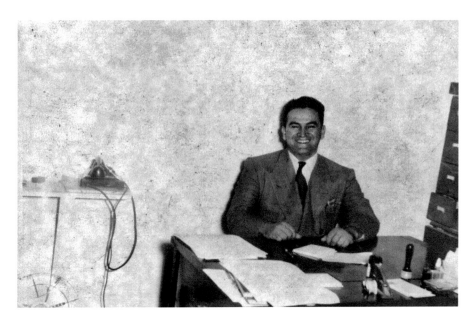

Dr. Héctor P. García in his first medical office in Corpus Christi, Texas, 1950. *Author's collection.*

The education and training at St. Joseph's Hospital would be challenging for Dr. Héctor. He was already licensed in Texas as a medical doctor; however, the conditions were very taxing for him. Coming from Texas from a deeply southern city in the Rio Grande Valley, which experienced no winters, he was thrown into a very different atmosphere. There were very cold winters and a new environment, and he did not know anyone. His training involved more direct patient care, to experience and study every diagnosis that came his way. He developed a problem list on each patient. He absorbed as much as he could.

However, a letter demonstrated his concern about his residency in Omaha, Nebraska. In a communication to Headquarters First Military Area, Office of the Executive, Federal Building, December 16, 1941, Dr. Héctor García stated that "my residency at St. Joseph's Hospital is not what I hoped it would be and want to be called to active duty immediately."[3]

My father definitely had problems with his residency and preferred to go into active duty at that time. I think he was worried about the potential loss of his infantry commission, which was set to expire in January 1943. However, he did remain in Omaha, Nebraska, until June 29, 1942, when he was finally called to active duty, completing his residency at St. Joseph's

Hospital. He was always grateful for the friendships he developed and the outstanding training he received in Omaha.

I had an opportunity to travel to Omaha with my father in 1975. I was able to meet with two of his classmates who were also residents with him at St. Joseph's Hospital: Dr. Kemp and Dr. Lemke. They both told me stories about my father, how kind, generous and friendly he was. He could make no enemies. Everyone liked and respected him as a medical doctor.

They both related a very unusual occurrence. Having arrived in Omaha in the winter, Dr. Héctor seemed unprepared to deal with the harsh winter conditions. He had no coat but never complained about the snow. His friends would ask him, "Dr. Héctor, where is your coat?" My father would respond in a laughing manner, "You people here in Omaha don't know what cold weather is really like." His fellow classmates were shocked at Dr. Héctor's response. How could a person live in Omaha in the dead of winter without a coat? How could he function and mobilize without proper clothing?

This was the reality of his life. He would never admit the truth—Dr. Héctor did not own a coat. He did not have the funds for one. His friends figured it out at a later time. They allowed my father to preserve his dignity. Understanding his pride and complex nature, they learned to admire him and respect him as a person. His life had been very different from that of the other physicians at St. Joseph's Hospital.

Unfortunately, I never met my grandmother Faustina Perez García. My grandfather passed on in 1957, when I was five years old. I remember meeting him several times. They would never realize what their strict discipline, education and love would produce. They could not have known that one of their sons would become a warrior, standing up for people who needed an education as well as for all veterans. Their son's advocacy would result in a better America, enacting laws to abolish segregation, pass civil rights and voting rights laws and improve access to healthcare—to be the voice for those who did not have a voice.

Jose and Faustina García would have been proud of Héctor P. García and all of their children. This was the type of son they hoped for. His diligence and perseverance was learned from his parents. They also taught their children community service. Even though his family lacked material goods, they learned to help others who were less fortunate than they were.

Héctor, their second son, made it through a very tough, unfriendly educational environment, attending segregated schools and graduating from University of Texas–Austin and then Galveston. Having top grades did not make the path easier for him, as he faced discrimination his whole life. He

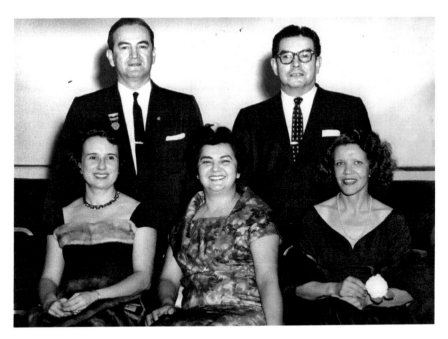

Left to right, standing: Dr. Héctor García and his brother Dr. J.A. García. *Left to right, seated*: Wanda García, Dr. Cleo García (Dr. Héctor's sister) and Wyona García (Dr. J.A. García's wife). *Author's collection.*

Wanda and Dr. Héctor García and his brother Dr. Xico and his wife, Yolanda, at wing dedication named after Dr. Héctor at Memorial Hospital Corpus Christi, Texas, June 12, 1993. *Author's collection.*

had the determination to fight so that he and others could succeed. His educational journey is one to study, analyze and admire, as we can all learn from a person who never gave up. He was smarter and emotionally and mentally stronger, achieving what was considered an impossible journey for an immigrant.

Immigration debates occur daily now, and I always tell the detractors to look at my father's life. As an immigrant, he made this a better country for his fellow man. He was always proud of his heritage and was able to foster relationships with everyone, regardless of their race or ethnicity. He was able to see and act beyond the barriers, as he knew early on that he was put on this earth for a reason: to help people medically and to help others live better lives by achieving the highest education levels possible. Dr. Héctor P. García was indeed able to accomplish what he envisioned for this country and for all Americans.

Chapter 2

MAJOR HÉCTOR P. GARCÍA, MD

When Héctor Perez García joined the Citizens Military Training Corps in 1929, he was not quite sixteen years old. Here was an early indication that he desired to serve his country in the military.[1] Always disciplined, young Héctor loved participating in sports, his studies and outside activities. He wanted to make his family proud of him, especially his father, Jose.

Joining the Citizens Military Training Corps would be very beneficial for young Héctor's future. He would gain knowledge regarding serving in the U.S. Army, enhance his interpersonal skills with his fellow cadets and respect and learn the chain of command, as he certainly would need it in the near future, as his credentials would be questioned at every level. Lieutenant García was commissioned as an infantry officer on June 8, 1935.

Evidence of my father's first commendation came on August 12, 1935, as a second lieutenant, 357th Infantry, Camp Bullis, Texas:[5]

> *The Commanding Officer, 357th Infantry, wishes to commend your actions, as Regimental Officer of the Day, during the storm on Saturday, August 10th 1934, and for securing the resumption of interrupted utilities service.*
> *By order of Colonel Tips:*
> *W.M. Dunham, Captain, 357th Infantry, Adjutant*

Young Héctor was twenty-one years old at the time of this commendation. I am certain that he was so proud to receive this, but I know that one

commendation would not have satisfied him; it would only make him work harder. The next known commendation was dated August 12, 1939, from Major C.C. Patterson:

Colonel Sylvan Lang, Commanding Officer
357ᵗʰ Infantry
Alamo National Building
San Antonio, Texas

My Dear Colonel Lang,

During the active training period, just closed, I had the privilege of having two young officers, under my command, serve with me in the Second Battalion of the 23ʳᵈ Infantry. These two young officers were: 1ˢᵗ Lt. Héctor P. García, from Mercedes, Texas and Lt. Theo A. Bowie, from San Benito, Texas.

Lt. García served as Communications Officer and Lt. Bowie served as Transportation Officer. Their work was very efficient, and I am glad to state that they performed all their duties in a most excellent and satisfactory manner, and I could not have had any more capable work and assistance than these young officers rendered.

While I expressed my personal thanks to these two young gentlemen before we left Camp Bullis, I feel that it is my duty to notify you, as their Commanding Officer, of their excellent service.

With Best personal regards, I remain,
C.C. Patterson, Major[6]

Having completed medical school at the University of Texas Medical Branch–Galveston in 1940, Héctor was ranked as a first lieutenant. He began to inquire about the next promotion available, which was captain of the infantry, on December 16, 1941.

First Lieutenant Héctor Perez García, MD, 357ᵗʰ Infantry-Res, made an inquiry to the Headquarters First Military Area, requesting the determination of his application for captain of infantry. He stated that he had already been refused examination on grounds of a corps conflict as to corps area requirements and that his papers had been sent back without consulting him.[7] His letter to the headquarters details the completion of multiple corps courses and the completed hours to obtain the certificate of capacity:

I am eager to acquire my certificate of capacity so that I can in turn transfer to the Medical Corps immediately and go into active duty at once. The army is in need of doctors and I am willing to go at once and I have on questionnaires expressed desire for foreign duty if necessary. Confidentially my residency at this hospital is not at all what I hoped it would be and my services here are not vital or necessary to the hospital, so that I am willing to be called to active duty in either the Infantry or Medical Corps.

Please advise me as to Certificate of Capacity and again I offer my services in time of emergency to my country.

Héctor Perez García, M.D.
1ˢᵗ Lt. 357ᵗʰ Inf-Ref

There were several letters between First Lieutenant García and Headquarters First Military Area regarding transfer from the infantry to the Medical Corps. Dr. Héctor decided that he would not wait for the commission he sought in the Medical Corps Reserve. Since he could not obtain his immediate transfer to the Medical Corps Reserve, and as he already was a licensed physician in the state of Texas, on March 18, 1942, he requested a deferment from active duty to stay in Omaha, Nebraska, to complete his residency. This was granted,[8] and Dr. Héctor was told by letter:

Effective January 1, 1942, the peacetime systems of promotion prescribed for Reserve officers were discontinued and all previous instruction of the subject of promotion of officers were revoked.

You cannot be promoted until you go to active duty. It is suggested you request duty with Medical Reserve Corps and after a short period of demonstration as to your efficiency it is believed chances for Captaincy would be excellent and you would almost certainly be promoted.

On June 15, 1942, First Lieutenant Héctor Perez García at St. Joseph's Hospital was called by telegram to active duty on June 29, 1942, to Fort Omaha, Nebraska. If physically qualified, he would report to Camp Edwards, Massachusetts, reporting to commanding officer engineer amphibian command for duty. Dr. Héctor was able to complete his surgical residency at St. Joseph's Hospital, as he had requested.[9]

My father continued to press for acceptance into the Medical Corps. He had been called to active duty on June 29, and his application was reported lost by the U.S. Army—another setback and delay for him. Yet he would

prevail, as on July 29, 1942, his application for transfer to the Medical Corps was instituted and approved, and he was promoted to the next higher grade. His movement from first lieutenant of the Infantry Reserves to the Medical Corps was finally realized on August 15, 1942. However, his promotion to captain from first lieutenant was not afforded to him until September 18, 1942, at which point his oath of office for this promotion was lost by the U.S. Army.

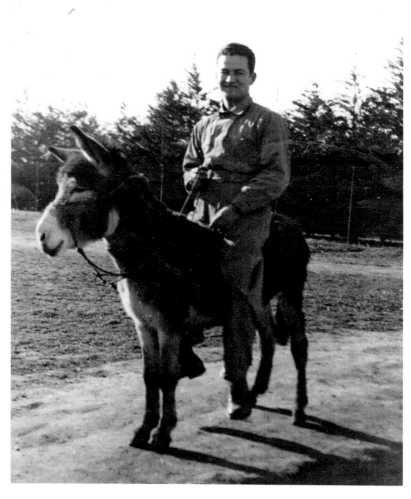

Dr. Héctor borrowed a donkey from a Moor—the results being a "cute donkey," January 22, 1943. *Author's collection.*

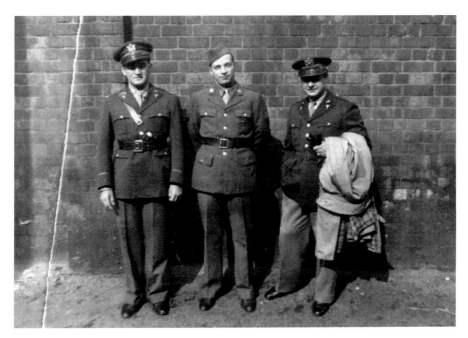

Above: Dr. Héctor with fellow officers in England, 1942. *Author's collection.*

Right: Captain Héctor P. García, MD, Medical Corps, North Africa, 1942. *Author's collection.*

My father's career and service to this country were indeed stellar and meritorious. He received a recommendation for the awarding of the Bronze Star Medal on May 31, 1945:[10]

To the Commanding General, Seventh Army, APO 758, U.S. Army.

Proposed Citation:
Héctor P. García, 0-324114, Captain, MC, Medical Detachment, 597 Engineer Combat Group, U.S. Army, for Meritorious service not involving participation in aerial flight, from 17 July 1942 to 29 May 1945. Captain García's outstanding diligence and loyalty to duty have manifested itself by the remarkable record attained by this organization and is in keeping with the highest tradition of the Medical Corps. Enter military service from Mercedes, Texas.

William F. Weiler,
Colonel, C.E.,
Commanding.

My father received several commendations for his superior service in the U.S. Army; his separation documents dated March 1, 1946, detail the course of all of his awards:[11]

- *The Bronze Star Medal, 9/20/45*
- *European-African-Middle Eastern Campaign Medal with 6 Bronze Stars*
- *World War II Victory Medal*

He served in Rhineland, Tunisia, French Algeria, Naples-Foggia, Rome, Arno and central Europe.

He separated from the U.S. Army on March 1, 1946, as captain medical unit commander and staff surgeon. He had supported combat operations and went beyond the boundaries prescribed. My father also continued to pursue another promotion from the U.S. Army. On January 3, 1947, he was finally promoted to the rank of major, receiving this after separation from the army, with an effective date of relief of March 1, 1946.

All of these commendations, officer promotions and red tape to achieve the highest military level possible demonstrates my father's perseverance in life. He was rejected on numerous occasions and was told of lost applications, but he was never distracted and did what was necessary to achieve what he

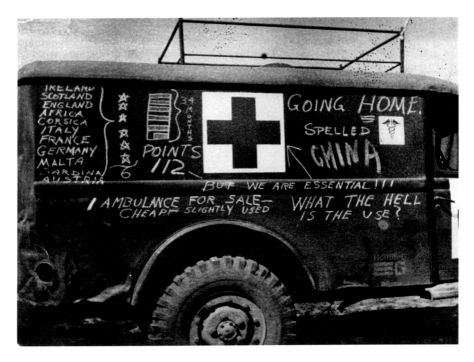

Above: An old faithful ambulance with "going home" sentiments at end of World War II, July 26, 1945. *Author's collection.*

Right: Dr. Héctor somewhere in North Africa during World War II, wearing a "fez," local headgear, 1942. *Author's collection.*

Dr. Héctor with a fellow soldier somewhere in North Africa, 1942. *Author's collection.*

wanted. Having a medical degree proved to be his salvation, as he continued to educate his officers as to his correct military status and educational level. He had been preparing for this since he was fifteen years old. One can only admire his achievements in the military.

He once told me about an encounter with General Patton in Italy at a surgical unit. General Patton approached my father and commented, "Dr.

García. What medical school in Mexico did you graduate from?" My father replied politely, "The University of Texas Medical Branch–Galveston, Sir." My father smiled and said that General Patton had a look of disbelief and walked off without saying a word.

Another interesting note is that my father did not receive his U.S. citizenship until November 7, 1946. He had performed at the highest level; gave this country meritorious service; medically assisted thousands of soldiers in combat; educated others about malaria, tuberculosis and venereal disease processes; and met a beautiful young woman named Wanda Fusillo, in Naples, Italy, whom he married on June 23, 1945.[12]

Dr. Héctor P. García would achieve a high rank in the military, but he would never forget about the soldiers who fought with him in World War II. He felt an obligation to all the military members he would encounter through the organization he founded, the American GI Forum. This was clearly evident during the Vietnam War. He was very saddened by all the soldiers who were being returned to Corpus Christi to their families after being killed in this war. He made efforts every day to comfort these families. He would be notified when one of these young men would be returning to his family in a coffin. He would make arrangements with other American GI Forum members to meet the returning soldiers at the Corpus Christi Naval Air Station or the airport, regardless of the time of day. If needed, my father would refer the families to a local funeral home for interment and funeral services at a very low cost. The funeral home was happy to assist these families at my father's request.

My father would attend the funerals of these young men and would often speak at the services. I asked him one morning why was he going so early to greet these soldiers? He had been working an eighteen-hour day, well into the night and morning taking care of his patients. He replied, "Because I have to go. It is the least that I can do for them." There was always a sadness in his eyes when he was getting ready to leave to greet the soldiers every morning for the services. He would not miss any of them. He felt it was his obligation to make sure the soldiers and their families would be taken care of at this sad time.

Reviewing my father's military records was a very tedious process. I am elated that I was able to study and understand this important aspect of his life, though, and his determination to succeed helped me understand how complex an individual he really was. He would never take no for an answer. I saw this time and time again in my life.

We can all look to Major Héctor P. García, MD, as a role model for our youth and ourselves, someone who can serve to instruct our children about

the benefits of a higher education. We can all learn from his determination to succeed. His life in the military is just one example of a person who desired to achieve the American dream, took responsibility seriously and never made excuses for himself or what was occurring around him. I have definitely learned in my lifetime how to persevere and try to be an example for others. He had achieved independence in his life but was also able to develop lasting relationships around him. He understood the values of trust and love for his fellow man yet he never forgot that he was called to serve all the people around him, through his medical practice and by assisting veterans through the organization he founded, the American GI Forum.

THE FOUNDING OF THE AMERICAN GI FORUM

In March 1946, after returning to Texas from World War II, Dr. Héctor P. García already had his plans formed in his mind for his people and returning Mexican American soldiers. He had witnessed the destruction of war, death of fellow soldiers and poverty. However, he would witness when returning to his country something else: broken promises.

Returning to the United States of America was an event filled with much excitement and anticipation. However, he had to leave his war bride in Naples, Italy. He had lacked the proper documents for citizenship, as becoming a citizen would not be completed until November 1946.

Dr. Héctor would join his elder brother in his medical practice for a brief time. In a few months, my father would open up his own medical practice, next door to the Veterans Administration in Corpus Christi, Texas. Dr. Héctor became the physician for returning veterans. He would care for each of them for only three dollars. This concept is what we describe today as a managed-care contract. Always ahead of his time, he understood the value of a constant workload. He wanted to serve all the veterans he could.

My father was a very good listener, and people trusted him. This opportunity to take care of returning soldiers would pave his way for something greater—the ability to assist thousands of veterans through his advocacy and through an organization that he would start.

The soldiers returning from World War II had many severe issues. Some were medical, but there were other issues that needed attention as well. The soldiers would discuss with Dr. Héctor many problems regarding education,

lack of income and the inability to find a job. Dr. Héctor would diligently listen to their troubles. He was formulating an action plan in his mind. He was touched by the soldiers' sacrifices for their country. Many of these soldiers would not be able to thrive due to a lack of education. Jobs were scarce if one did not have a formal education, more so if you happened to be Mexican American.

Dr. Héctor would join the League of United Latin American Citizens (LULAC) and would serve as its local president in 1947. LULAC had been founded in Corpus Christi, Texas, in 1929, mostly to end ethnic discrimination in the United States. The organization dealt with the issues of poverty, education and healthcare. Somehow, my father was not quite satisfied with the progress of LULAC as an organization. He had a deep commitment to veterans, whom he felt were not being given due focus by LULAC. He thought that he could do things in a different way.

In March 1948, a notice was sent out to all veterans for a meeting at Lamar Elementary School in Corpus Christi. The meeting was planned

Dr. Héctor (far left) and other World War II veterans formed the American GI Forum to protest the failure of the U.S. government to follow through on promised benefits. *García Papers, Special Collections and Archives, Bell Library, Texas A&M University–Corpus Christi.*

to have all veterans come together to join an organization to address the problems that they had encountered and would continue to experience if no action were taken immediately. On March 26, 1948, seven hundred veterans came together to organize and form the American GI Forum. The founder was Dr. Héctor P. García, who would lead the organization until his death in 1996.

Dr. Héctor had begun the organization's momentum. He would travel from city to city, county to county and state to state. He would organize

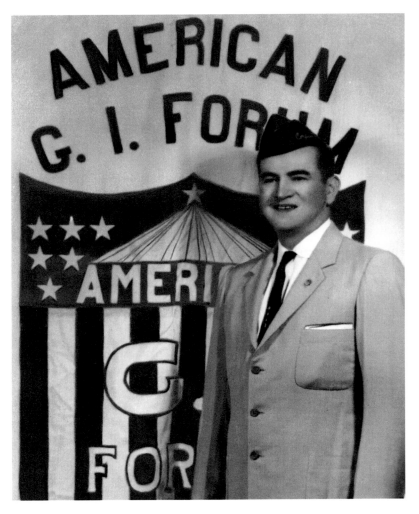

Dr. García standing before the banner of the newly formed American GI Forum of Texas. *Author's collection.*

veterans and their families. He sought family support to make the American GI Forum a successful organization. He knew the value of family assistance in his life. He would have the commitment of his wife, Wanda, who would serve as the organization's first secretary.

My cousin Tony Canales, the son of Dr. Cleo García, Dr. Héctor's sister, shared with me the early days of the American GI Forum when he would travel with my father around the country.[13] The goal was to organize the chapters in as many states as possible. Of course, in the beginning, Texas was hit the most aggressively by the early organizers.

Tony stated that my father possessed a letter of support and introduction from Catholic Bishop Mariano S. Garriga. Garriga became bishop of the Corpus Christi Diocese in 1949 and was responsible for bringing the Jesuit Fathers to the diocese and building the Corpus Christi Minor Seminary in 1960. This letter of support would pave the way for my father to have doors opened for him.[14]

Tony recalled being only thirteen years old and riding in the back seat along with all the American GI Forum paraphernalia. My father would always be prepared. Tony rode in the back seat of a white Mercury, Dr. Héctor's first car. Tony stated, "Dr. Héctor drove that white Mercury into the ground, and it would no longer be usable. So many miles on that car. Dr. Héctor next purchased a blue Cadillac. He was rather embarrassed to buy a Cadillac but felt it would serve him well."

Tony's first remembrances were those road trips. They went to Albuquerque, Omaha, Chicago, Pueblo and many trips to Odessa, Del Rio and Eagle Pass, Texas. Dr. Héctor would contact in advance people whom he knew to prepare for his arrival. A frequent passenger was Herbert Hernandez, who would ride with Tony in the back seat.

Tony stated that the organization would begin in a Catholic church: "If the town or city had a Lady of Guadalupe Church, he would hold meetings in the parish halls. Dr. Héctor would always speak about the issues facing them that were relevant to their lives and future. Dr. Héctor would organize a chapter, hold elections of officers, take many photographs and would always leave a chapter behind. That's how it was done."

Tony has fond memories of those early days with my father. He had several encounters with Vicente Ximenez of New Mexico and Dr. George Sanchez of Austin, Texas. One very touching remembrance was when my father instructed Dr. Cleo García to purchase a new white tuxedo jacket for Tony, as he was attending some formal events. Tony fondly recalled his first jacket, as he needed it when he was a young teenager. A trip to Disneyland

also occurred in those days. The early days with Dr. Héctor would be a tremendous influence on young Tony Canales, and he would forge a relationship with my father that would last a lifetime.

It was very time consuming to form a national organization. There would be many days away from home and his medical practice. My father would finance the entire American GI Forum movement with his own personal funds. The sacrifices would begin to build and take a toll on the family emotionally and financially.

My mother stayed with my father as much as she could. She had her second child in 1948. It was difficult for Wanda to continue assisting her husband as she had been doing for several years. Her obligations at home continued to build with her children, their education and her household duties. She had to stay at home and had increased responsibilities with the family as my father became more absent from home. Raising the family rested on the shoulders of Wanda, as my father was often gone from Corpus Christi while also attempting to maintain his thriving medical practice.

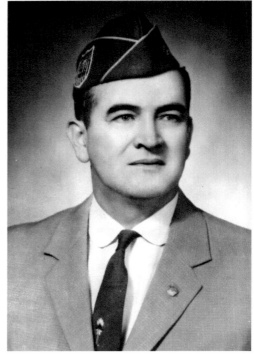

The focus of the American GI Forum dramatically changed in 1948. Toward the end of the year, a young woman named Mrs. Beatrice Longoria made a visit to Dr. Héctor P. García. A tragic event and set of unfortunate circumstances had brought Mrs. Longoria to meet with Dr. Héctor in Corpus Christi, Texas.

Mrs. Longoria was originally from Three Rivers, Texas, and had married Felix Longoria. They had one child, a daughter named Adeleta Longoria. Felix was a truck driver by trade; this is how he supported his family financially. Felix would also feel a sense of duty to his country. Many of his friends had enlisted to go fight during World War II.

Dr. Héctor P. García, founder of the American GI Forum, 1948. *Author's collection.*

He was twenty-six years old. According to Dr. Patrick J. Carroll's book *Felix Longoria's Wake:*[15]

> *The young man received his letter of acceptance into the military on November 11, 1944. Soon thereafter, he left his family and reported to active duty. After six weeks of basic training, Felix boarded a ship that brought him to Luzan for his first combat assignment as an infantryman. Soon afterwards, he volunteered to join a patrol with orders to dislodge enemy snipers.*

Private First Class Felix Longoria would give his life for this country on June 16, 1945, in an ambush. After his death, he would receive several medals from this country: a Bronze Service Star, a Purple Heart, a Good Conduct Medal and a Combat Infantryman's Badge. It would be three years after Private Longoria's death that Mrs. Longoria would have to deal with its aftereffects.

Mrs. Beatrice Longoria received notification from the army that it would be returning Felix's remains to San Francisco, California, and it requested the location from her to reinter him. Felix's parents still lived in Three Rivers, Texas, and even though Beatrice had moved to Corpus Christi to be with her parents, she decided to send Felix back home. Dealing with the tragedy of Felix's death must have been difficult for her and making a trip to Three Rivers must have been trying. She would be reliving Felix's death over and over in her head.

There was only one funeral home in Three Rivers. The Rice Funeral Home had a new mortician named Tom Kennedy. Mr. Kennedy was from Pennsylvania rather than Texas, and he had only been with Rice Funeral Home for less than a month.

The funeral home welcomed Mrs. Longoria to arrange for Felix's burial. Things went well in the discussions until the subject matter changed to Felix Longoria's wake. Beatrice wanted to use the chapel at the funeral home. However, Mr. Kennedy declined for an unbelievable reason: "The whites wouldn't like it." The response reverberated inside Beatrice's head, yet she reluctantly agreed. She must have felt such shock at his decision, but at that point, she had no one else to assist her. She returned to Corpus Christi and related the events to her sister Sara Posas and the rest of her family.

In the ensuing discussion, Beatrice sobbed as she attempted to explain what had happened. Felix, after all, was a decorated World War II hero and

had lost his life defending this country. How could Tom Kennedy overlook these facts? Sara was also shocked. Having experienced some discrimination at a much lower level in her hometown of Mathis, Texas, at a skating rink, she had enlisted the assistance of Dr. Héctor P. García. His intervention allowed Sara and her Mexican American friends to gain admission to the skating rink. Sara knew who to call to assist Beatrice with this more serious problem.

Sara visited Dr. Héctor to discuss the problem. He wanted to speak to Beatrice directly. Beatrice had already agreed to use a vacated bungalow to wake her husband; however, it was not clean and lacked electricity, furniture and water. She deeply regretted agreeing to these terms for Felix's wake. Then Dr. Héctor called Tom Kennedy. Mr. Kennedy confirmed over the phone that he had denied the use of the chapel for Felix's wake. He stated again that the "whites wouldn't like it and that Mexicans got drunk and got into fights." He was again denied the use of the chapel.

My father quickly went into action. This was not acceptable to him. He contacted the media and sent out seventeen telegrams, including one to President Truman. He received one response that would be useful: an offer to give Felix the burial that he was entitled to as a World War II hero. It was January 1949. The only helpful response came from newly elected senator Lyndon B. Johnson of Texas, who wrote via telegram:

> *I deeply regret that the prejudice of some individuals extends even beyond this life. I have no authority over civilian funeral homes, nor does the federal government. I have today made arrangements to have Felix Longoria buried with full military honors in Arlington National Cemetery here in Washington, where the honored dead of our Nations' wars rest.*[16]

Private First Class Felix Longoria was interred in Arlington National Cemetery on February 16, 1946. My father knew that there was a Felix Longoria somewhere. He knew of discrimination and prejudice. This was the case that would propel Dr. Héctor García to the national stage.

Private First Class Felix Longoria would become a national war hero who represented the sad state of our country at that time. Senator Lyndon B. Johnson would later become president in 1963 after President Kennedy's assassination and would pass major civil rights legislation. Tom Kennedy and the Rice Funeral Home never really recovered from this incident, nor would Three Rivers, Texas. My father was soon advocating for veterans at a national level. The direction of American GI Forum would soon turn to civil rights.

The year 1950 was a very tumultuous time in our country. There were three historic cases regarding the Fourteenth Amendment, civil rights and segregation. In 1950, Pete Hernandez, a migrant cotton picker, was accused of murdering Joe Espinoza in Edna, Texas, where no person of Mexican origin had served on a jury for at least twenty-five years. Hernandez was found guilty, and the decision was upheld by the Texas Court of Criminal Appeals.

The *Hernandez* case was viewed as a challenge to the systematic exclusion of persons of Mexican origin from all types of jury duty in at least seventy counties in Texas. The Supreme Court of the United States heard the arguments on January 11, 1954. Gus García, James DeAnda and Chris Alderete of the American GI Forum and Carlos Cadena and John J. Herrera of LULAC argued that the Fourteenth Amendment guarantees protection on the basis of not only race but also class. The state attempted to argue that this was a coincidence rather than a pattern of attitude or harassment. However, in Jackson County, discrimination and segregation were common practices, and Mexican Americans were treated as a class apart.[17]

Chief Justice Earl Warren delivered the unanimous opinion in favor of Hernandez and ordered a reversal of conviction. The court found that when laws produce unusual and different treatment on such a class, the constitutional guarantee of equal protection is violated. The court held that Hernandez had "the right to be indicted and tried by juries from which all members of his class are not systematically excluded." This opinion was the precedent that civil rights groups were able to utilize for many years to argue that segregation of Mexican origin persons was illegal in the absence of state law.

The next landmark case was *Brown v. Board of Education* in 1954, which addressed the constitutional legality of race-based segregation of children into "separate but equal" public schools.[18] Segregation of children in the public schools solely on the basis of race denies to nonwhite children the equal protection of the laws guaranteed by the Fourteenth Amendment even though the physical facilities and other tangible factors of white and black schools may be equal. Education in public schools is a right that must be made available to all on equal terms. Separating nonwhite children from others solely because of their race generates a feeling of inferiority as to their status in the community that may affect their hearts and minds, which in turn affects the motivation of a child to learn.

The opinion was decided on May 17, 1954, and delivered by Chief Justice Earl Warren in summation:

Segregation of white and colored children in public schools has a detrimental effect upon the colored children. The impact is greater when it has the sanctions of the laws, for the policy of separating the races is usually interpreted as denoting the inferiority of the Negro group. A sense of inferiority affects the motivation of the child to learn. Segregation with the sanctions of law, therefore, has a tendency to [retard] the education and mental development of Negro children and to deprive them of some of the benefits they would receive in a racially integrated school system. We conclude that, in the field of public education, the doctrine of "separate but equal" has no place. Separate educational facilities are inherently unequal. Therefore, we hold that the plaintiffs and others similarly situated for whom the actions have been brought are, by reason of the segregation complained of, deprived of the equal protection of the laws guaranteed by the 14th Amendment.

These two cases, *Hernandez v. Texas* and *Brown v. Board of Education*, would pave the way for the most important battle that would occur in Corpus Christi, Texas, regarding education: *Cisneros v. Corpus Christi Independent School District*, filed in 1968. The *Cisneros* case would set a new precedent after the *Hernandez* case, as it recognized Hispanics as an identifiable minority group and utilized the *Brown* decision of 1954 to prohibit segregation.

Cisneros v. Corpus Christi Independent School District was important because it identified that the Corpus Christi Independent School District systematically and purposefully enforced segregation of Mexican American and black students, which denied them a quality and complete education and ensured the failure of these minority groups in their future.[19]

Dr. Héctor P. García and the American GI Forum were well on their way to guaranteeing quality education for all children and establishing veterans' rights as promised by this country. Besides the victories that the organization experienced in education and against segregation, veterans' issues were also at the forefront of the agenda of the American GI Forum. The organization worked tirelessly to expose the problems that veterans were experiencing, provide financial assistance and advocate that all veterans would receive proper healthcare, jobs and education.

The organization prospered under my father's leadership for many years. It continued to grow to hundreds of thousands of members and expanded to thirty-three states. The organization's members banded together and respected one another, their mission and their leader.

Dr. Héctor García was a powerful force, nationally recognized, and his accomplishments were well known. He had led the American GI Forum

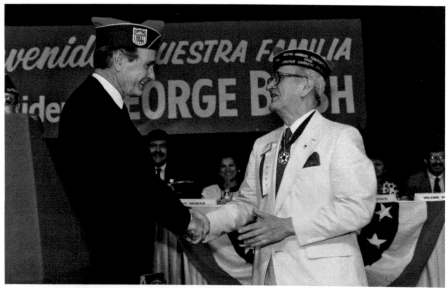

To Hector Garcia with best wishes, Ceo. Bush

President George H.W. Bush with Dr. García at the American GI Forum National Convention, August 1988. *White House Photograph.*

to national prominence. Together they would get major legislation passed, become the largest Mexican American veterans' organization in the country and become recognized for its veterans and civil rights advocacy on a national level.

The end of an era was coming. The dynamics began to shift within the organization. Younger Forumeers wanted to attempt to lead the American GI Forum. Dr. Héctor was getting older and had some serious health issues in the 1980s. Some began to challenge him and his leadership of the organization.

In 1988, Dr. Héctor and Wanda came to San Antonio to visit me and Jimmy, but there was also a convention of the National American GI Forum. My father was excited to be there; however, he had some serious concerns at that time. He felt that the shift in the organization was detrimental to its mission. He was unhappy about this new direction and wanted to restore it to the early years. After all, veterans' needs had not changed much, and most Mexican Americans still faced issues with their education. Some civil rights

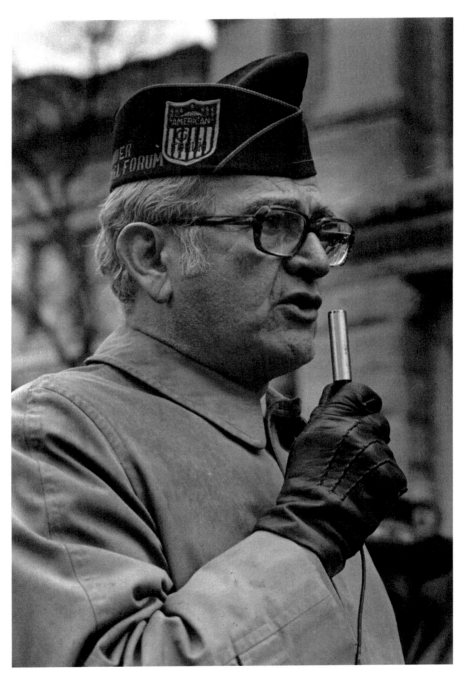

Dr. García addressing rally at the state capitol in Austin, Texas, 1989. *Author's collection.*

cases had been settled, but there was more to do. The war was not over for Dr. Héctor.

My father attempted to take control of the organization that he loved. He had been its leader for more than forty years. He would be very shocked and disappointed at the next sequence of events. He decided to run for national commander. He was seventy-four years old and had already been through several heart surgeries. His desire to have better control of the organization was overtaking him to the point that he could not be objective about his own needs.

He ran for national commander, and he lost. He was devastated. He returned to my house and told us what happened at the convention. I was shocked at the turn of events. Trying to comfort him was futile. There was a mixture of anger, disappointment and disbelief. He felt that there were some members who had turned against him. And it was obvious that they had, in my opinion. The discussion went to his need to pull away from the American GI Forum. I reminded him that he had some major surgeries recently and that maybe this would be the next course to take. He would not listen to my reasoning. He and my mother immediately packed and left to return to Corpus Christi. His plans began to change soon after that convention.

For his entire life, he had planned for a museum to archive his papers and photographs. Part of the plan was to house the documents in his office in Corpus Christi. He had thought that he could add on to it or build additional buildings on the lots that he owned. However, his possessions were so massive that this plan was not viable in the long run.

He was approached by Corpus Christi State University to house his documents and provide for research capabilities. Even though there were other major universities that wanted this historic opportunity, he signed a donor's agreement in 1990 with Corpus Christi. He wanted to keep the collection near him. The university soon began to collect his documents and photographs. It was an arduous task. No one really knew how many documents existed; however, this massive donation turned out to be the most comprehensive collection that existed regarding the Mexican American civil rights movement.

Topics were varied and included healthcare, veterans' rights, education and civil rights. The collection, called the Héctor P. García Papers, would expand to more than seven hundred linear feet of paper and more than five thousand photographs. He knew that he needed professionals trained in archival storage and a massive amount of space. Realizing that there were no opportunities for the American GI Forum to handle his

collection, he changed his will in 1995 by a codicil to leave his building to my mother, Wanda, instead of the National Archives and Historical Foundation of the American GI Forum. He stated to me, "I am changing my will to leave my building to Wanda, so when I die she will have some money when she sells it."

In 1995, the year preceding his death, he had started planning for the end of his life. At that point, the American GI Forum was not the organization he had founded, and he had learned to let it go. Even though he attended some events, his health prevented him from being very active like he had been, and he was very disappointed in the direction and focus of the organization he had founded and to which he had dedicated his entire life.

July 26, 1996, would be the end of my father's life. The family had a private viewing of him in his casket. He lay there peacefully but looked tired and worn. He had his American GI Forum founders cap draped over his right shoulder. In approaching his casket, I could not stop thinking about the cap that would be buried with him. My thoughts were that the American GI Forum, as the organization that we had known and loved, would also be buried with him that day.

The American GI Forum began to self-destruct two weeks after my father's passing. Internal conflicts and posturing for power and control began to plague it. It lost its national prominence, financially and morally. The organization had lost not only its founder but also its leader. It was proven over time and after several negative occurrences that a leader for the organization would not surface. Dr. Héctor P. García would always remain the organization's only leader, as he had made the sacrifices and spurred the efforts to make the American GI Forum what it was when he founded it in 1948 and throughout the span of his life.

As my cousin Tony Canales stated to me, "Leadership? He was the leader who ran the show. No one could match him."

THE DEATH OF THE NAMESAKE

Héctor García Jr. was born on July 25, 1948, in Corpus Christi, Texas. The second child and only son born to my father and mother, he certainly entered the world during a tumultuous period in my parents' life.

Young Héctor ("Sonny") was a very precocious child. Being the only son and bearing my father's name carried certain expectations and responsibilities. At an early age, the expectations were that young Héctor would do well in school, become a physician and get involved in the American GI Forum. Dr. Héctor certainly needed to groom a leader in his family; young Héctor was not only handsome and intelligent, but he also possessed certain qualities that made people gravitate toward him. He was charming, polite, pleasant and respectful. I am certain that my father saw his son in his own image, possessing the same qualities he did, and he knew that he was going to be a reflection of him someday.

Young Héctor did not disappoint my parents. He had movie star looks and was very popular at St. Patrick's Catholic School in Corpus Christi, Texas. Sonny did very well in school and was already looking forward to the next adventure. When he was a young child, he developed a kidney infection that resulted in one of his kidneys operating at a very low functional level. This infection would later become a contributor to his untimely death. This illness caused Sonny to miss school to recover; however, he did recover and resumed his normal activities.

While attending St. Patrick's, young Héctor developed his love of sports and his strong Catholic faith. He did not know until much later in life that

his love of sports was passed on from father to son. While Héctor García Sr. attended Mercedes High School, he was involved in track and was a class reporter for *The Tiger*, the monthly newspaper of the senior class of Mercedes High School.[20] His being a reporter at *The Tiger* and being involved in journalism would always have special significance for me as I was growing up. My father's love of sports had a strong influence on young Héctor's life.[21]

Héctor Jr. loved baseball. He loved the New York Yankees, especially Mickey Mantle and Roger Maris. He could not tolerate the Boston Red Socks; why this was so I never knew, but I followed my brother's lead on this and trusted him. He somehow obtained a cap, baseball bat and paraphernalia all related to the Yankees. I think that my father probably purchased Sonny's equipment for him, as Sonny could not drive yet to purchase these things. He received everything he needed to be successful

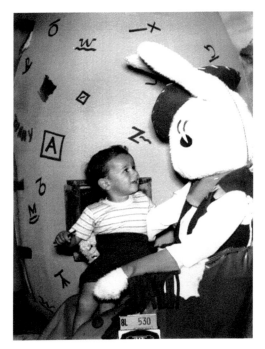

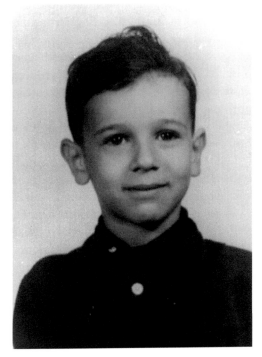

Top: Héctor García Jr. with the Easter bunny, 1953. *Author's collection.*

Right: School photo of Héctor García Jr. ("Sonny"), 1954. *Author's collection.*

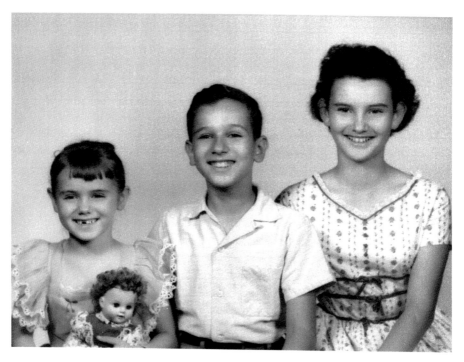

Cecilia, Sonny and Daisy, 1958. *Author's collection.*

at baseball. Every day after school, we would toss balls and practice our batting. Since Sony was only four years older than me and liked many of the same things, such as biking and sports, we were able to spend many hours together, developing our bond with all the things we appreciated and liked.

Life was not easy on Peerman Place in Corpus Christi, Texas. Moving to a new home in 1959, we were promised a good life, a good education and the ability to prosper in an upscale, all-white neighborhood. Young Héctor was eleven years old, and I was seven years old.

My father wanted to move to a nicer neighborhood and build a home that would accommodate his larger family. He was unable to purchase the lot in the neighborhood he wanted due to his ethnicity and his already established reputation. So, he had his friend and attorney James DeAnda purchase the lot for him in Lamar Park so that my father was able to build his dream home unrecognized and unmolested, or so he thought.

The home on Peerman Place was stunningly beautiful. The house was custom-built on a large corner lot with a multitude of oaks and beautifully landscaped by my mother, Wanda. Ms. Wanda saw to every detail of the

new home. She wanted a showcase where she could raise her four children, entertain and cook her Italian meals.

There were so many things we could not predict but only imagine. I could not understand the hostilities and the insults that were thrown at us daily and the hatred that we experienced from the public. My siblings, particularly young Héctor, did not accept the insults hurled at us by the neighborhood children. No one wanted to have anything to do with us. My father was hated for his advocacy, but his children were also hated. We had very few friends.

Dr. Héctor thought that sending us to a Catholic school would spare us some controversy, but the hatred and jealousy existed there also. The sisters at St. Patrick's attempted to shield us, pray with us and protect us. I will always appreciate their kindness toward us. I think the sisters did the best they could; however, having your father in the news every day did not help matters. I realized that the hatred came from the parents, who were afraid of my father and feared change. There were some parents we encountered who did not want to see us or other Mexican American families thrive and succeed.

Young Héctor became involved in some brawls in the neighborhood. One time, he was injured and scared as one of the older boys tried to choke him. We learned to fight back at that point, but Sonny was very protective of our father. As a family, we fought this hatred well into the 1970s. Even today, if I hear any insult toward my father, my mind roars back to those days, trying to find an answer to the hatred toward us. Being so much older now, I rationalize to myself that the actions of these young people were products of their parents' fear of change. My parents were both highly educated, kind, drove nice cars and wore nice clothes. We had the best. However, others in the neighborhood, city and state did not advocate for Hispanics to have the same rights, education and material goods as they had. Obtaining a higher educational level was only a dream for most. Having a nice car, house and clothes was not obtainable for the majority of Hispanics.

All of us were devoted to the Catholic Church. We all attended schools that were private Catholic educational institutions. Young Héctor developed a love for the church. As a young child, he became an altar boy and assisted in many Masses. My parents, particularly my mother, encouraged him to participate as much as possible in church activities. As the years went by, young Héctor became even more devoted to his church and the Catholic religion. Attending Catholic school, we had religion classes daily and went to Mass every morning and on Sundays. We never missed church unless we were so ill that we could not walk that day. Sonny sought comfort in his religion, as I did. We prayed for strength, good

grades, good health, our parents, teachers and everything else. We said our prayers every night at bedtime.

Héctor Jr. decided at an early age that he wanted to become a priest. Shortly after his graduation from St. Patrick's Catholic School, he entered Corpus Christi Seminary. We missed him terribly. I recall that he was gone two weeks from home. The entire family dropped him off at the seminary to say goodbye. He seemed suited for this new role. He was so excited and happy—an unbelievable opportunity to be on his own for the first time. He was going to explore this vision that he had only dreamed about.

My father was surprisingly supportive as his only son entered the seminary that day. I know that my father wanted his children to do well academically and spiritually. He wanted us to succeed at our chosen professions and provided us with the necessary tools to achieve our goals.

Young Héctor's time at the seminary seemed to pass slowly. We all wrote letters to Sonny. One poignant letter from my mother, written in June 1962, stated, "We were happy to receive your letter and cards this morning. I am glad that you like the seminary and that you adjusted to the schedule. We will pick you up Friday morning and will be happy to have you back. Be a good boy. We love you."[22] I also wrote a letter to my beloved brother while he was in the seminary:

> *I am glad you miss Sheba "Kitty" and me. I didn't forget to feed the dog once. I am glad you are coming home soon. How is everything down there? Well, everything is fine here. The letter from Model Market didn't come. I think we didn't win. Did you write to you know who? I like the post card you sent me. Susie liked hers. She ate all the mangos. We miss you very much. You are lucky to go swimming. I bet L.D. will come all happy. Sorry I can't write any more. P.S. I have a new hairdo, please try to write back.*

We all loved our brother, and he certainly was a great brother and role model even at the young age of thirteen. He was soon admitted to Corpus Christi Academy with his acceptance letter to continue his Catholic education.[23] Young Héctor's life was full of promise and excitement. We all supported him, and my parents were looking forward to their only son furthering his Catholic education in high school.

It was a bright and early Sunday morning in July 1962 when young Héctor was packed and ready to go on his trip to Morelia, Michoacán, Mexico. He was traveling with his elder sister, Daisy García, and another family to stay for an extended vacation and to learn Spanish.

That morning, young Héctor was so excited. I was in bed because it was still very early, but I could hear all the commotion in his room. He had one large suitcase ready to go. On his way out, he came to say goodbye to me and tossed me one of his favorite baseball pamphlets. He said, "Goodbye, Squirt. I got this for you." I was so surprised that he had given me the pamphlet that he used and cherished. I said, "Bye, Sonny. Come back soon." That was the last time I would see my beloved brother alive.

The next day, my mother received a telephone call from my father. Her face turned grim, and her voice lowered. She told me that Sonny was in an accident and that they were leaving immediately to Morelia, Mexico. She said that Sonny was climbing up some steps on a mountain and fell. Unfortunately, he fell on his only functioning kidney and went into shock. My parents decided to drive to Mexico. My father's main confidant and friend, Santiago Castro, was going to drive them. My mother's plan was to bring her beloved son home in the Cadillac, resting his head in her lap for the trip.

My parents drove straight for days, through the rain and mountains, trying to reach young Héctor. My mother said that when they reached the hospital, everyone was wearing black. Dr. Xico García, my father's younger brother, came to greet them. My father started shaking his head in disbelief, and my mother knew immediately that they had not made it in time to see their only son before he passed on. That date was July 17, 1962.

Things were very intense from that point on. My father had to request assistance from Congressman John Young to have Héctor Jr.'s body returned to Corpus Christi. The ladies who were staying with us at home told me about my brother's passing. I was only nine years old. My father arrived home first and then Daisy García and my mother on another day.

I will never forget my father's appearance when he arrived at the house. The first question to me was if they had told me about Sonny. I responded that they had. After that, he didn't say another word. He started weeping and weeping for hours. I attempted to comfort him by hugging him. He would not let me go.

The grieving had begun. We were lost without young Héctor, and we all took it very hard. The next few days were filled with company, friends, family and mourners. We had food and desserts, and hundreds of plants were sent to the house. We were never left alone. Preparing for Sonny's funeral was an arduous task. When we arrived at the funeral home, my mother lost control. Gazing at Sonny in the casket was a shocking moment for her, and she wept openly. My father felt tremendous guilt for sending him on that trip to Mexico. I feel that this guilt never left my father for the rest of his life.

My father never left Sonny's side at the funeral parlor. He stayed through the night and only returned home in the morning to change his clothes. Hundreds and hundreds of people came to offer their love and condolences. The funeral was beautiful and perfect. All of Sonny's classmates were lined up outside St. Patrick's Catholic Church to greet us and the casket. It was unbelievable that this nightmare was happening to us.

After the funeral was over, a few weeks later, I noticed that my father never mentioned Sonny again. Growing up, I could never understand his grieving process. However, I did notice that my father's workload became more intense. President John Kennedy was assassinated on November 22, 1963, and that also was a dagger in my father's heart. He began to take on some intense projects, such as civil rights and voting rights legislation. There was a high-profile lawsuit, *Cisneros v. Corpus Christi Independent School District*, that lasted several years. My father received numerous awards and recognition, including serving as alternate representative to the United Nations in 1967 and on the U.S. Commission on Civil Rights in 1968; he also accompanied Vice President Hubert Humphrey and the U.S. delegation for the signing of the Treaty of Tlatelolco in 1967. My father had become a true public servant.

My mother, Wanda, left my brother's room intact for many years, just as he had it when he left for Mexico that morning. She would go into the room daily to pray and silently weep. She would look at his pictures that she had in many areas of our home. The crucifix that had draped his coffin had a permanent place on his bed. She had a difficult time dealing with his death and was reminded every day of her loss.

So my father channeled his grief in a positive manner. Not accepting this until much later in life, I had a full understanding when my father was on his own death bed and called out for his only son, "Mi hijo!" My father had always grieved for young Héctor Jr. but maintained his strength and love for his family through his work. He knew that he would draw from the death of his only son strength for the years ahead of him.

In saying goodbye to my beloved brother, I remember him lying peacefully in that white casket. It was very disturbing to see him there and not running around with me, playing baseball. I remember my last kiss to him on his forehead. I told him how much I missed him and how much I will miss being with him and not growing up with him. Somehow I knew that he would always be with me and watch over me. I would never forget him.

Chapter 5

MY SWEET
SIXTEENTH BIRTHDAY

It was my sixteenth birthday. That morning, I was planning out my day, which would have included swimming, a party and plenty of ice cream and cake. I planned to see my friends that day, even though there were not many friends around us. I could always count on Shirley and Milton to help me celebrate.

Shirley Tolin was my very best friend from grammar school at St. Patrick's Catholic School. We did everything together while growing up. Shirley had meals at my house several times a week. My mother loved cooking for her, and my father treated her like one of his daughters. My father would fill his Cadillac up with loose coins placed over his visor. While he was napping, we would raid his car of all his change, walk to Lamar Park Drugstore and treat ourselves to ice cream sodas. We did not realize that my father purposely filled his visor up to watch us raid his car from the study window. We thought he was napping, but he was being "Papa," enjoying watching his daughter trying to trick her father.

Shirley and I grew up together in Corpus Christi, Texas, during a very tumultuous era in the 1960s. We both attended Catholic schools, became cheerleaders and tried to study hard, but we were just teenagers. The sisters at Incarnate Word Academy put up with our laughter, short skirts and playful attitudes. We were good teenagers—there wasn't much to really get us into trouble in those days. Shirley was my only true friend, someone to confide in and someone who stood by me and my family when we were hated by almost everyone.

Cecilia García as a young teenager in Corpus Christi, 1963. *Author's collection.*

My father watched us like a hawk though. He limited our outside activities and our attendance at school functions. My mother was more liberal, not wanting us to be homebound, but she was also very careful about our relationships with others. They tried to insulate us from the hatred and anger, but we could not always escape it. The hatred was not ever going to leave. Shirley and I had the same interests, and we stuck together. I was able to live as normal a life as possible. I studied hard, had few friends, fought off all the bad influences, loved the Beatles and loved going to the beach. We did not have to worry about material things; however, while growing up, I could never accept the hatred toward my kind, beloved father.

Milton Storey and his family were from North Carolina and arrived in Corpus Christi in the summer of 1965. The Storeys definitely personified "southern charm," as I called it. They were very polite, engaging and generous and loved to have poolside parties and dinners. They were deeply devoted Presbyterians. I know the Storeys could not have predicted what would come their way moving to Texas, nor would they be prepared.

My father was an advocate for his people and patients. He was in the news daily, fighting for his people and trying to change the environment. He would single-handedly, if necessary, fight segregation, improve access to healthcare, ensure benefits to Mexican American veterans and enhance educational opportunities for minorities.

Even though Papa was so controversial, the Storeys and Shirley understood that he was sincere and determined about his causes. Even though my father liked the Storeys, he was not too pleased about my developing relationship with Milton. Papa did not want boys as a distraction to good grades. He had issues regarding Milton being my first boyfriend and also living across the street from me. We were inseparable. We did have opposing political views, though, which was very irritating to me. However, the political discussions would always change to funny stories.

Shirley, Milton and I were friends for life. I still consider them members of my family and still cherish all the years we spent together. They were with me during the critical years and at the important events while we were growing up. Shirley Tolin greatly honored me by being a bridesmaid in my wedding. It was so appropriate to have her with me for this wonderful event in my life.

Cecilia García and Milton Storey at the Holiday Ball, 1969. *Author's collection.*

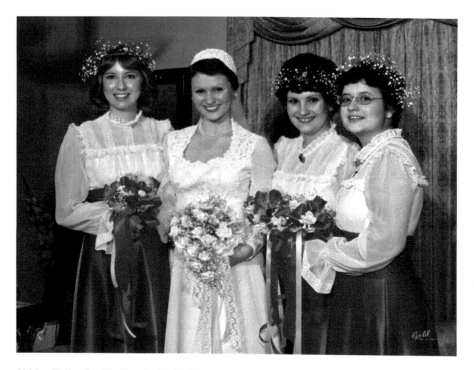

Shirley Tolin, Cecilia García, Daisy García and Susie García at Cecilia's wedding, January 28, 1978. *Gold's Photography.*

I learned from my father to always respect others' views. I think that his influence on me taught me to be nonjudgmental of others' lifestyles, race, ethnicity and religion. I learned some hard lessons, beginning on my sixteenth birthday. This day was the first day of my adult life.

It was early for me on August 2, 1968. Papa approached my room, sat down on my bed and told me that I was going to the office with him. I looked at him incredulously. Not today, I told him. My father was not going to take no for an answer. He told me that it was about time I learned about the real world. He was going to teach me about life and work beginning that day. I later realized that he had confidence in me and that I was the one most like him of his children.

When he arrived at his office on Bright Street, his waiting room was filled with patients. They would wait as long as necessary to see their beloved doctor, as he did not work by appointments. I was assigned to Emma Hernandez, his bookkeeper and manager. He had a nurse, Mary Escobar, and a full-time staff. Promptly, Mary showed me how to take

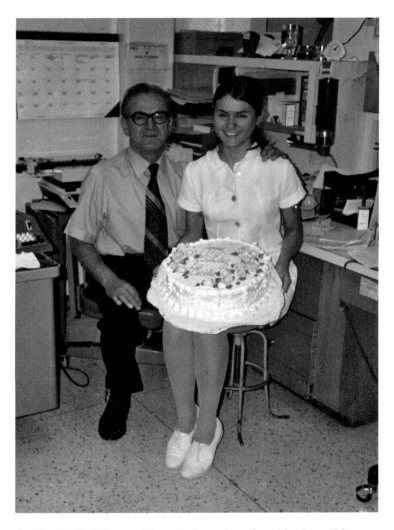

Cecilia with Dr. Héctor at his medical practice office with a beautiful eighteenth birthday cake, 1970. *Author's collection.*

blood pressures, check temperatures and pulses and how to take histories. My father was very disciplined about his practice. I was given the title "Medical Assistant to Dr. Héctor P. García." I was very proud of that title. Mary Escobar put me to work immediately.

Being the daughter of Dr. Héctor, the boss, did not afford me any luxuries. And being the new kid on the block, I had to work myself up the ladder of importance. So, I was assigned the daily breakfast duty of purchasing tacos

and sweet breads for all of the staff. I would drive up and down Morgan Avenue, seeking out the best Mexican food I could find. I would bring back the orders, and we would have fresh, hot coffee. All of this came before the boss arrived at the office. We all had so much fun at the medical clinic of Dr. Héctor. Emma, Mary and I would always start a new diet every Monday morning; however, it would be over by that afternoon, when my father would send out for hamburgers and fries.

My employment with my father lasted ten years. I considered working for him the greatest blessing and opportunity in my life. He did not spare me one thing. I saw every illness, diagnosis and minor surgery that came to his practice. I witnessed impending death. I went with him on daily hospital rounds. I learned how to prioritize and organize my schedule because, while working for him, I was going to school and studying to gain admittance to a physical therapy program. My father's dream was for me to become a medical doctor and work with him in his clinic. I am certain that his investment in me was as not only an employee of his but also a future partner.

Working with my father was a challenge. He was demanding of my time with him. I sensed his urgency to get someone to help him for the future. He would not just have anyone there with him. We had daily study sessions of medical terminology and medical practice. I loved making hospital rounds with him and seeing patients with him in his office. This employment gave me the greatest opportunity to learn Spanish, as the majority of his patients spoke only that language.

The rounds were educational at Memorial Hospital. He always had the nurses' attention, as he would hand out gum and candy to them. One of my favorite memories was when we were on the hospital floors making rounds, and my father would always introduce me and tell the nurses, "Don't be jealous, ladies. This is my daughter, Cecilia." They would answer back, "Dr. Héctor, she is too pretty to be your daughter." We would both smile and laugh politely.

My father was always pleasant but serious about his work. His patients came first. He never failed to tell his patients what was important in their care. He would diagnose, educate, lecture his patients and assist them with referrals elsewhere if needed. My father was the consummate primary care physician of his time. The majority of his patients were the poorest of the poor. He would tell me time and again that medicine is not a science—it is an art. That is how he would explain his cases that were difficult and not easily diagnosed and treated. Medicine is indeed an art.

In the late 1940s and 1950s, my father had a radio program on which he would discuss illnesses such as diabetes and tuberculosis and provide information on diets, vaccinations and medications. He was not in medicine to make a ton of money but rather to help others. He took care of them regardless of their ability to pay. He believed that education was the key to a healthy lifestyle, and most of his patients did not have immediate access to the needed information. His obligation to his patients extended beyond his office practice. I noticed that he openly referred patients to specialists. He would personally call the specialist on the telephone, refer the patient and send the patient immediately over to be seen. No one would tell my father, "No, not now." It just didn't happen that way.

He would see all his patients at the hospital and follow their care. His explanation of the patient's chart, diagnostic procedures and information and interaction with other professionals was invaluable to me as I grew and developed professionally. I would never receive this training anywhere else, especially from a book.

My father's medical practice consisted mostly of patients who lacked the ability to pay for their care. However, my father was also the personal physician to the Sisters of the Incarnate Word and Blessed Sacrament. Many of his patients were my own teachers during high school. He would receive a call from the Incarnate Word Convent, requesting his assistance with one or some of the sisters who were ill that day. Most of the sisters were unable to visit their doctor in his office. After receiving the call from the convent, he would pack his small medical bag, filled with medications, syringes, a blood pressure cuff, thermometers and anything else he thought he might need for the cases. He had already triaged the patients over the phone to be prepared to take care of them. He would then make his way to the convent in his car to care for everyone who needed him. He never charged the sisters for the care he provided to them. Helping others was the reason he had become a doctor. In return, the sisters did not charge my father or mother for his daughters' education at Incarnate Word Academy. This was their way to give back to him for the excellent care he had delivered to them for so many years.

We were able to have lunch daily, usually at Rosita's Mexican Restaurant or the Chicken Shack. It was the best quiet time together to learn from him, understand him and share our lives together. He would also discuss politics and his activities with the American GI Forum. I knew then that if I had not gone with him on my sixteenth birthday, I would not have ever gotten to know my father or who he was. Because of his schedule and his activities, our time together as a family was very limited. I will always cherish

those times as a God-given opportunity to enjoy his company and have him mentor me. This relationship prepared me for the rest of my life, and I am eternally grateful for everything he taught me.

My father would also help people on a daily basis who needed a "favor" from him. People who came to visit him would have to wait until he had time in between his patients. Many visitors were politicians seeking his advice and support. Other people needed his assistance in one way or another. Dr. Héctor never discussed these requests with others. That is why people trusted him and had confidence in him. He never let others know how he had affected a stranger's life. He never boasted, bragged or talked about his successes. He always would take his personal time to help others. He was truly there for anyone who would come to see him.

Soon it was time for me to finish my education and graduate from the School of Allied Health Sciences at the University of Texas Medical Branch– Galveston. It seemed that I had been going to school forever. Graduating as a physical therapist from a prestigious school, and the same school from which my father graduated, was a tremendous source of pride for me. On the day of the graduation ceremonies, the entire García family went to lunch at Guidos Seafood Restaurant. Though I was proud of my accomplishment of completing a rigorous physical therapy curriculum, my complacency only lasted about one hour, until my father calmly asked the question, "Adriana [my first name; Dr. Héctor used it more than Cecilia], when are you going to take the MCAT [Medical College Admission Test]?" I was floored and almost choked on my seafood. My soon-to-be-husband, Jimmy, was shocked, and my mother just stared at my father. I tried to explain to my father that I had been in school since kindergarten and that I wanted to get a job and start working in my new profession. I also had to pass my physical therapy licensure exam in Texas in a few months and had to diligently study for it. I know that I must have stuttered as I spoke to him. He just looked at me, and after I had said all of these defensive statements, he replied, "I think you should take it just for the heck of it to see how you do." It was an incredulous moment for me. Not only was I fatigued from school and examinations, but I also had to begin to find a job, plan a wedding, pass a do-or-die licensure exam and move to the city I would be working in for my first job. The MCAT had no room in these plans of mine. Plus, I had no available cash, and finances were a struggle. I would be on my own now financially. I wanted to go to work as soon as possible.

Having secured a job in San Antonio, I began the trek there with Jimmy and my cat, Ricky. I was ready to start this new chapter in my life. It would be difficult, challenging and rewarding to be a physical therapist. I would be a

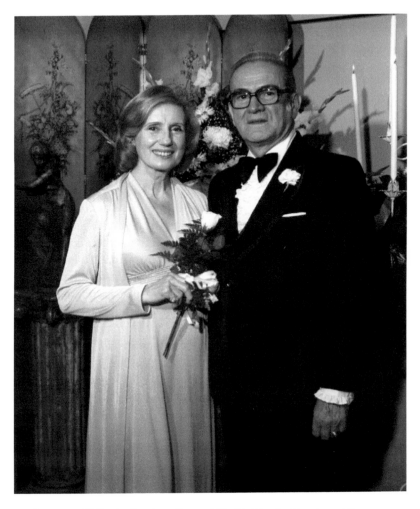

Dr. Héctor and Wanda García at Jim and Cecilia García Akers's wedding, January 28, 1978, in Corpus Christi. *Gold's Photography.*

staff physical therapist at a hospital in northeast San Antonio. I learned to be a good physical therapist and moved up the career ladder in management, as well as in teaching at area professional programs. I was satisfied with my career choices. Sometimes I do wonder what would have happened if I had gone to medical school and worked alongside my father. I do know that he was not open to having any other physician with him. I know that he was terribly disappointed that I did not join him in his practice, but he did move on eventually from this decision I had made, even though it took him about eight years.

We were together at an American GI Forum National Convention in Wichita Falls, Texas, in 1985. He had asked me to speak to the youth membership that would be attending the convention. I always liked to give speeches in public, especially about my profession in physical therapy. I knew that I had really made it when, after I had finished speaking to the group, my father got up and stated, "I have always thought that the only professions that you could be successful in were medicine and law. But today I say to you to become a physical therapist like my daughter." After the luncheon, I was the recipient of the American GI Forum Women's Hall of Fame Award. I was totally surprised and honored. I knew then, after I had practiced for eight years as a physical therapist, that he had finally accepted the profession and my choice. We would then have numerous discussions about patient care and patient outcomes. We shared many experiences together regarding our professions. He did value my profession as a clinician finally and was proud of what I had become. He had taught me the independence I would need to make the choices in my life.

In our travels across Texas and the United States, my husband, Jim, and I meet many people who tell us how their lives were touched by my father. Many relate incidences of how he took care of them medically. Others told me that he had delivered them at Memorial Hospital or had made house calls back in the day. We have heard numerous stories about his advocacy for veterans, families and people needing medical care.

One young man from Corpus Christi told us that he had been drafted and was being sent to Vietnam. He said that he had requested a delay in his deployment because his first baby was expected in a few weeks. His request was denied by the U.S. Army, and he was sent to training. His family decided to go visit my father to ask for his assistance. One week later, this young soldier returned to Corpus Christi to be with his family for the birth of his first child.

There are hundreds of people and stories like this across the country. We hear them all the time, in person and on social media. It is a remarkable thing that one person could make such a difference in other people's lives. He did so quietly and without pomp. He did these things because he could help others by making an effort, knowing who to contact and not taking no for an answer. He understood that he had been put on this earth for this reason.

I finally understood and accepted that we were both helping people to regain their lives and their health and to achieve positive outcomes. Yet we were doing it in different ways, he as a physician and I as a physical therapist. I was fortunate that I had worked alongside the very best primary care physician I had ever known.

AMBASSADOR
HÉCTOR P. GARCÍA

I t was the summer of 1967. My father was his usual controversial self, fighting for his favorite issues of education, assisting veterans and healthcare. The case against the Corpus Christi Independent School District was rapidly escalating, and he was making the news on a daily basis. He knew how to use the media and was not shy about challenging them. But he was always kind to every reporter and had close relationships with several of them.

I was in high school in 1967 at Incarnate Word Academy. The family would have dinner together every evening at our home so my father could join us. He would eat the meal my mother had diligently prepared for us. We always would have challenging discussions about current national events at the dinner table, and later he would relax by watching television with us.

One night after dinner, my father explained that he had received a phone call from the White House. He stated that President Lyndon Johnson wanted to appoint him as an ambassador to the United Nations. This would mean he would have to leave Corpus Christi, his medical practice and his family. He would have to move to New York City for his term. We were shocked but so proud of him. I was especially surprised given all the controversies he had in his life since 1948. However, he always had a solid relationship with President Johnson. It was contentious at times, as my father would never change his focus on his own specific goals. But he did have the ear of the president of the United States.

In the following weeks, there were Federal Bureau of Investigation (FBI) agents dispatched to Corpus Christi. The agents watched our home and

spoke to several of our neighbors. One family would be the Storeys, as they lived right across the street. Mr. and Mrs. Storey did not know my father that well, but they knew my mother, Wanda, and us children. We had interacted almost daily with the Storeys. Apparently, the agents asked the Storeys many

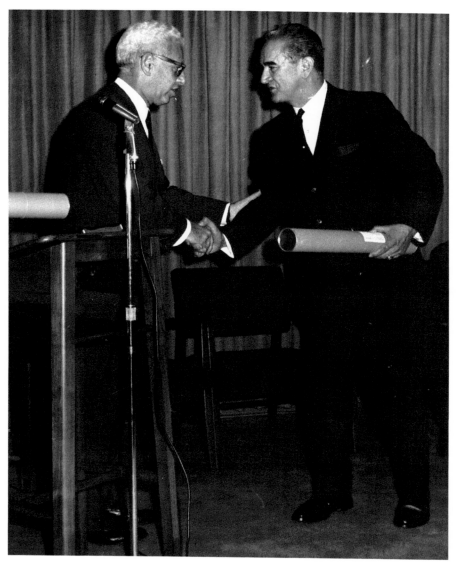

Dr. García receiving his commission to the United Nations from Ambassador Arthur Goldberg, September 20, 1967. *Author's collection.*

questions about my father and his family. Mr. Storey told me that he had diplomatically answered to the agents' questions by saying, "I really do not know Dr. García very well, but he does have a very nice family."

That was probably the best endorsement that was needed. Dr. Héctor had done a good job with his family, so he must in turn be a good, honorable person. He would make a wonderful ambassador to the United Nations, representing our country and making history in the process.

When my father's appointment was announced to the public, of course, he faced criticism from others. Most were from people who never knew my father. The criticism was that he was not deserving of such an honor, that he had somehow manipulated his way into this appointment or that a Mexican should not receive such a designation. He would disprove all of this criticism.

My father left his medical practice to his sister, Dr. Cleo García. Being appointed to the United Nations would be a sacrifice financially. His salary would be only $100 per day. The assistance from Dr. Cleo would keep his medical practice going in my father's absence.

On September 20, 1967, Dr. Héctor P. García received his commission from Ambassador Arthur Goldberg, chief of the U.S. Mission at the United Nations.[24] This was a wonderful, exciting time for my father. His official title was United States alternate representative, United Nations General Assembly. Excited but humbled, he moved to New York to make his residence in the Roosevelt Hotel in September 1967. Soon after his arrival to the United Nations, he received the following letter, dated October 11, 1967:

Dear Mr. García:

It gives me great pleasure, on behalf of the President, to accord you the personal rank of Ambassador during your tenure on the United States Delegation to the Twenty-second Session of the United Nations General Assembly.[25]

Sincerely,
Dean Rusk
Secretary of State
Washington

The commission noted:

Know Ye, that reposing special trust and confidence in the Integrity and Ability of Héctor P. García, of Texas, I have nominated and

by and with the advice and consent of the Senate, do designate him an Alternate Representative of the United States of America to the Twenty-second Session of the General Assembly of the United Nations, and do authorize and empower him to execute and fulfil the duties of this commission, according to law, with all the powers and privileges thereunto of right appertaining during the pleasure of the President of the United States.

In Testimony whereof, I have caused these Letters to be made Patent and the Seal of the United States to be hereunto affixed.

Done at the City of Washington this twenty-second day of September in the year of our Lord one thousand nine hundred and sixty-seven, and of the Independence of the United States of America the one hundred and ninety-second.

By the President *Lyndon Johnson*

My father was now Ambassador Héctor P. García. He would be the first Mexican American who would receive this type of appointment by the president of the United States to the United Nations.

Dr. Héctor arrived in New York and faced very cold weather. Much like his life in Omaha, Nebraska, his time in New York was difficult with the constant cold and living out of a hotel. His life was more opulent, though, than when he lived in Nebraska. He would walk and take taxi cabs everywhere. He had access to the United Nations' restaurants, as well as all of its facilities and limousines. He wore expensive coats, gloves and hats. His life had really transformed to that of a diplomat in New York City. Of course, he became to know everyone. My father had a very engaging personality and was easily liked by anyone who met him. He was very popular at the United Nations, and it was apparent that he was also well respected.

My family planned a trip to New York City for November 1967 for the Thanksgiving holiday. We were so excited to be able to see my father again and to go to New York City. It was a very busy holiday. We stayed in the Roosevelt Hotel. It was so cold that we would put food on the window ledge outside to keep things refrigerated.

We also had to dress up everywhere we would go. I really liked that part of the trip. Being a young teenager, I had to buy new clothes, shoes and hats for this trip. Of course, my mother always looked absolutely stunning. She was elated to be with her husband again. She seemed to like the attention we were getting from the New Yorkers.

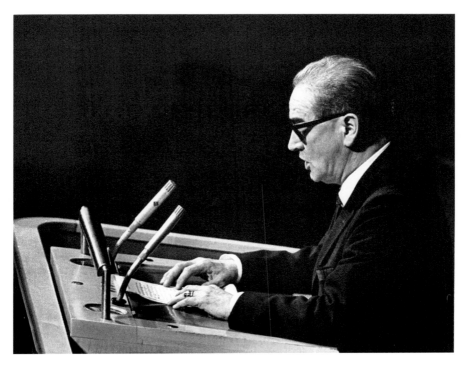

Dr. García delivering the historical address to the General Assembly of the United Nations, New York City, 1967. *García Papers, Special Collections and Archives, Bell Library, Texas A&M University–Corpus Christi.*

Before our arrival in New York City, my father was involved in a historical event. Being a U.S. ambassador, he was afforded the opportunity to speak to the General Assembly. He prepared his speech on nuclear weapons not in English but in Spanish. One of the primary reasons he had received this appointment from President Johnson was to improve relations with Latin America.

On October 26, 1967, the speech to the United Nations was given in Spanish, and he was the first U.S. representative to speak before the United Nations in a language other than English. He had accomplished something very extraordinary. I asked him this question, "How did you learn enough about nuclear weapons to give a speech in Spanish?" He explained that he had a staff that helped him research the topic, and he was able to translate the speech into Spanish. He acted like it was not a major event, but it really was historical. His whole life would turn out to be a monumental experience.

Apparently, the Russian delegation could not accept that an American could make a speech in a language other than English. They had said

publicly that Dr. Héctor had been coached. They thought that all Americans could speak only one language: English.

He had made history again, this time at the United Nations. An opportunity arose, and he took it to the highest level. He was happy that the Russians had questioned his abilities. He was accustomed to the controversy, and this time, it had manifested itself at the United Nations.

My father soon began to really miss his medical practice, his family and his life in Corpus Christi. It was late in 1967. His time at the United Nations was coming to an end. He was tired of the lifestyle in New York City. He was a long way from his family. Even though he had many visitors from Texas come to see him at the United Nations, it was not the same as being in Texas. My father resigned his commission effective December 1967. He received a certificate of appreciation that read:[26]

> *Know all men by these present that the members of the United Nations do hereby express to Ambassador Héctor P. García, M.D. their admiration and respect for the high sense of public responsibility which he unfailingly demonstrated in his devoted service to this Mission and his Government during the Twenty-Second Session to the United Nations General Assembly, and their appreciation for his Friendship, Counsel, and Support.*
>
> *December 10, 1967*
> *Attest: Arthur J. Goldberg*
> *Chief of Mission*

Dr. Héctor P. García's time at the United Nations would transform him. He had exposure to a worldwide audience, he had achieved a historical accomplishment by speaking in Spanish to the United Nations General Assembly and he would become a respected statesman for the United States. The public's perception of my father would begin to turn positively in his favor.

My father returned to Corpus Christi to prepare for the lawsuit against the Corpus Christi Independent School District, which was filed in 1968. He returned to his medical practice, family and friends, as well as to his beloved Wanda.

THE DESEGREGATION OF PUBLIC SCHOOLS IN CORPUS CHRISTI, TEXAS

D r. Héctor P. García's main emphasis in his life was education. He wanted everyone to achieve the highest education level possible, including his children. My father despised poverty, yet he was surrounded by it in his adult life. Most of his patients were of poverty level, could not speak English and had achieved only a minimal education. Most had dropped out of grammar school, and the majority of his patients had no knowledge of their own disease management.

One of the daily occurrences that my father encountered was the presence of children in his office, mostly accompanying their parents at medical visits. He had supplied the children a color television in his waiting room, a water fountain and a fish tank full of guppies. The children did not mind waiting. There was also a pharmacy next door where snacks and drinks could be obtained.

My father knew that those children were attending subpar schools. He could tell that the educational level they would obtain would be minimal, and most were not fluent in proper English. He feared the children of his patients would not be able to succeed in life, but instead would live in poverty like their parents. They would be subject to illness, incarceration, drugs and death. He had witnessed the worst scenario since returning from World War II. He knew that there had to be better solutions for these children, to be afforded better opportunities in life for them.

Dr. Héctor would tour, analyze and document with his own camera the atrocities he would witness at the schools in Corpus Christi, Texas. I was able

to tour one school with him, Stephen F. Austin Elementary. The restrooms were filthy; it had outdoor water fountains that were not maintained and broken windows. It was a very crowded environment, which meant that there were way too many students per classroom.

Having attended a private Catholic school, I was shocked at what I saw there—a school that was part of the Corpus Christi Independent School District, not in a third-world country. How could students be expected to attend this school, rise from a lower educational level and succeed in life? There was no way the children could be productive citizens in their future. My father knew all of these things. He wondered how he could fix these problems for the Mexican American children and for the children of his patients.

James DeAnda was a brilliant attorney. He had been the legal advisor for the American GI Forum for many years but also was one of the plaintiff's attorneys in *Hernandez v. Texas*. DeAnda wrote briefs for the *Hernandez* case and worked alongside Gus García, Carlos Cadena and John J. Herrera. DeAnda had extensive civil rights trial experience. He also was a close personal friend of my father's and a wonderful human being, full of humor and kindness. He spent many hours in our house visiting and being supportive of my father. My father and my family called him "Jimmy."

The history of the Corpus Christi Independent School District was not an admirable one regarding quality education for minority children. Its history of segregation went back many years, but the earliest documentation was in September 1955, when black students who were previously enrolled in all-white schools were being bused to all-black schools in Corpus Christi.[27]

There were many attempts by black leaders to convince Dr. Dana Williams, superintendent of Corpus Christi Independent School District, to take action on several levels. There were also numerous complaints by parents and the public about the problems in these black schools and the lack of policy from the school district. On February 15, 1966, there was a bond issue proposition that included building a new high school in the Agnes-Lexington area, as well as a new elementary and one junior high school, which passed. The new high school would be Moody High School.

Black and Mexican American leaders complained of segregation in the boundary lines drawn for the new Moody High School. The chairman of the National Association for the Advancement of Colored People

(NAACP) formally complained of segregation at Moody High School in June 1967 to the U.S. Office of Education in Washington, D.C., regarding gerrymandering, segregation and discriminatory assignment of classroom teachers and principals. There was also a petition filed by black and Mexican American leaders requesting investigation of the Moody boundary line.

De facto segregation was found to exist because of "lack of foresight of previous planners in regard to a high school system and in light of neighborhood isolation" by a subcommittee of the city council in Corpus Christi. There were numerous appeals by the NAACP and other organizations to desegregate area schools. However, the Corpus Christi Independent School District failed to take action and tried to convince the public that there were no discriminatory practices in the district schools.

The tension in the community continued to build. There were many press conferences to expose the inadequacies of the Corpus Christi Independent School District and of Dr. Dana Williams. On July 22, 1968, José Cisneros and others (thirty-two plaintiffs in all) filed a lawsuit against the Corpus Christi Independent School District, with the cost of the suit paid for by private funds from the United States Steel Workers Union. The lead attorney for the case would be James DeAnda. My father and all of the plaintiffs were certain that they would prevail.

Soon after this historic lawsuit was filed, the Department of Health, Education and Welfare wrote to Dr. Dana Williams in October 1968 with its findings. The extensive analysis of the conditions of the schools and the school district policies were, in fact, labeled as violations of Title VI of the Civil Rights Act of 1964 and the department's Title VI regulation:[28]

> *Under Title VI and the Regulation, schools and school systems are responsible for assuring that the services, facilities, activities and programs which they conduct or sponsor, or with which they are affiliated, are free from discrimination on the grounds of race, color or national origin. Each school system has the affirmative duty under law to take prompt and effective action to eliminate such segregation or other discrimination, and to correct the effects of post discrimination.*

The specific results of the report demonstrated the violations that the Corpus Christi Independent School District had within its organization:

While the district has made progress toward the elimination of discriminatory practices in the hiring and assignments of its faculty and administration, this process has not been completed.

The effect of the sequence system is to assign the majority of Mexican-American and Negro students to courses in sequence III and IV from which entry into college is difficult if not impossible.

Sites for new schools have been selected in certain locations with the effect of preparatory identifiable minority group schools.

Certain boundary lines have been drawn with the effect of perpetuating minority group schools. In particular, the southern boundary of Moody High School so as to remove a significant number of Anglos from the Moody attendance zone.

The facilities in the Mexican-American areas are older than the facilities in the predominantly Anglo areas and the maintenance and upkeep of the Anglo schools is superior to that of the Mexican-American.

The schools in the Mexican-American areas are more crowded than the schools in the predominantly Anglo areas, with the utilization of more portable buildings. At the same time, there are empty classrooms in the predominantly Anglo schools.

In general the school board has been much more responsive to the needs and desires of the Anglo community than to those of the Mexican-American and Negro residents.

We believe the matters described above constitute severe problems of compliance under Title VI of the Civil Rights Act of 1964 and we urge that the school district take prompt action to resolve them.

Lloyd R. Henderson
Education Branch Chief
Office of Civil Rights

The details of this blistering report were made public. One would think that Dr. Dana Williams would take immediate action, which would have been the responsible course for a superintendent and the school board. The battle would continue as my father became very aggressive in his criticism of Dr. Dana Williams.

My father's office became the "Grand Central Station" of Corpus Christi. Everyone involved in the lawsuit would meet there to strategize and plan the outcome. James DeAnda was known as the best in his field. This

lawsuit would be the turning point for my father's advocacy and the public's awareness of his mission.

On June 4, 1970, Judge Woodrow Seals passed down a Partial Final Judgment:[29]

> *It is therefore* ORDERED, ADJUDGED *and* DECREED *by the court that the present assignment of Negro and Mexican-American standards by the defendant Corpus Christi Independent School District does not conform to law, and that its Board of Trustees, and their successors in office, officers and employees are permanently enjoined from discriminating on the basis of race, color or ethnic origin in the assignment of students, teachers and staff of the various schools of the district, and shall take the following affirmative action.*
>
> *Assign teachers and staff personnel to various schools so as to eliminate either racial or ethnic identifiability of any schools in the system.*
>
> *In the consideration of new schools or expansion of existing facilities give consideration to the achievement or preservation of a reasonable mixture of Mexican-American and Negro students with other students in each such new or expanded facility.*
>
> *File in this court on or before July 15, 1970, a plan for the revised assignment of the student population to be effective fall of 1970, to indicate the relocation of boundaries, pairing of schools, bussing or other device which will promote the objective of a unitary school district, and finally, the court finds that this judgement involves a controlling question of law as to which there is substantial ground for differences of opinion insofar as this court has reordered judgement that Mexican-Americans are an identifiable ethnic group who are subject to the protection of the 14th Amendment of the Constitution and of the laws of the United States and have been subjected to both de jure and de facto segregation.*
>
> *Woodrow Seals*
> *United States District Judge*

On the day of the opinion by Judge Woodrow Seals, I was working with my father in his office. One of my duties was to answer the telephone and take messages. Urgent phone calls would go to my father directly. The phone did ring that day, and the caller was Dr. Dana Williams. I went to notify my father, and he stated that he would go speak to him after he finished with his patient. He went into his inner office and closed the door. A few minutes

later, he came out of his office and started writing some notes. I became very curious and asked the question, "So, what did Dr. Dana Williams want?" My father explained, "He called to ask for my help because he does not know what to do with the court order." I responded to my father, "So, are you going down to the school district's office to help him?' Again, my father very nonchalantly stated, "As soon as I finish with my work, I am going down to help him because he does not know what to do to integrate the schools."

I was shocked at this point. My father and Dr. Williams had a very public battle, with some choice words spoken about character and the need for Dr. Williams to resign. I think that this one incident demonstrated my father's true commitment to the education of children and to their future. He was able to put aside all of the criticism and insults that were thrown back and forth because my father had achieved the results he was seeking. Mexican Americans being an identifiable ethnic group protected by the Fourteenth Amendment is exactly what the lawsuit intended to establish, and they were successful.

This court order was the answer to the plaintiff's lawsuit. The plaintiffs successfully proved that a dual school system existed and that integration must occur. However, this joyous event would be brief, as Dr. Héctor García issued a passionate but scathing press release dated August 29, 1970, demanding Dr. Dana Williams's resignation due to his failure to formulate a lawful integration plan. The "Williams Plan" would have grouped black and Mexican American students together with a token representation of both groups in the predominately Anglo schools. My father submitted the press release with the following statements:[30]

> If we are to understand, respect, and love each other, if we are really wanting our country to COME TOGETHER, if we are to work together for a greater America, then it is of the greatest importance that all three groups of children be brought together in the halls of learning under the guidance of wise teachers so that the children can study together, eat together and play together and get to know each other. This can only be done by abolishing the present dual school system and as required by law to have a real American "UNITARY" system. This must include Negro teachers and Mexican-American teachers using their talent to teach the "ANGLO STUDENTS" also. Before it is too late, let us gather our children under one roof and give them all the best schooling and the best teachers. This Dr. Williams has not chosen to do or cannot do. So that someone else can achieve this objective, he should resign.

Dr. Héctor P. García (center) with several students at a Corpus Christi Independent School District sit-in to protest against school segregation that led to his arrest along with the students', August 1972. *García Papers, Special Collections and Archives, Bell Library, Texas A&M University–Corpus Christi.*

There were several court actions by the Corpus Christi Independent School District that resulted in a total stay of the desegregation plan granted by Judge Owen Cox on August 23, 1971. My father and James DeAnda would not give up. A very effective tactic, taken by my father and several students in August 1972, was participation in a "sit-in" at the Corpus Christi Independent School District. Dr. Dana Williams and others tried to convince the "participants" to leave the building. The police were called, and everyone, including my father, was hauled off to jail. A short time later, my father was offered the opportunity to leave. However, he told the officers that he wanted to stay with the others. He would not leave. Dr. Williams decided to let everyone out since the media was approaching. My father called my mother, Wanda, at home. She was shocked and yelled, "You're in jail!?"

Dr. Héctor was happy about it. He had made his point, and the media reported about the jail time. He had gotten the public's attention now, and

he felt that things would move forward. The next evening, my father held a community meeting. Hundreds of people attended, along with students and the media. He had successfully brought people of every walk of life together. It was a brilliant strategic move to promote his cause and involve all interested parties. He had successfully exposed the discrimination and segregation that had existed for so many years and that would, he hoped, end very soon.

The battle continued, and in May 1975, Judge Cox ordered Corpus Christi Independent School District to create a plan to integrate the schools. A new school system would be produced. An unpopular busing plan followed, a plan that would take years to implement. There were angry parents and students; however, in the end, it was necessary and accepted that this would have to occur for the benefit of the educational system and the children's future.[31]

After the lawsuit was over and the plan was in effect, the public's perception toward my father changed dramatically. I noticed that when we were in public or at restaurants, people would come up to him, shake his hand and thank him for what he had done for the children of Corpus Christi, Texas.

A few years later, in 1984, Dr. Héctor P. García would be the recipient of the Presidential Medal of Freedom. One day, I told him, "Papa, who would have ever thought it would end up this way?" My father just smiled, shook his head quietly and said, "Right, who would have ever thought?"

This one cause, as well as the efforts of many people, patience and determination, would change the course of the history of education in Corpus Christi. My father would then be perceived as a hero and no longer a troublemaker. I would later fully understand his course of action regarding the educational needs of these children. He would always be a hero to me.

Chapter 8

THE PRESIDENTIAL
MEDAL OF FREEDOM

The Presidential Medal of Freedom is the highest civilian award in the United States and is bestowed by the president of the United States. It is designed to recognize individuals who have made "an especially meritorious contribution to the security or national interests of the United States, world peace, cultural or other significant public or private endeavors." Although a civilian award created by executive order, the medal can be bestowed on and worn by military personnel.

The Presidential Medal of Freedom ranks second only to the Medal of Honor, issued by the United States Congress, which is the nation's highest military award. Unlike the Medal of Honor, the Presidential Medal of Freedom is generally not awarded for solitary actions. The award is conferred only after careful deliberation of a lifetime of service from a distinguished career.

The Presidential Medal of Freedom was established by President Harry Truman in 1945 to honor service during World War II. The three people who were the first recipients were all women, and only one was an American citizen: Anna M. Rosenberg, Andree de Jongh and Marie Louise Dissard.[32]

President John F. Kennedy revived the medal in 1963 through Executive Order and expanded its purpose. The revival began in 1962 following a Gallup poll indicating that Americans favored the establishment of some sort of "National Honors List" to recognize individuals who made outstanding contributions to the nation in such endeavors as the arts, science, literature, education, religion or community service. Within three months of the

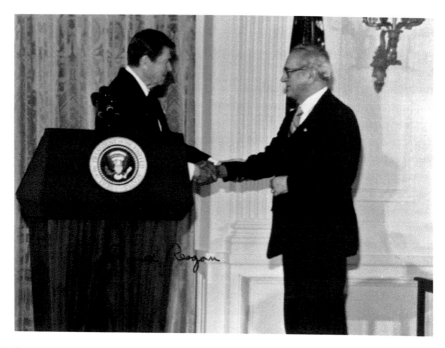

President Ronald Reagan presenting the Presidential Medal of Freedom to Dr. García, March 26, 1984. *White House Photo.*

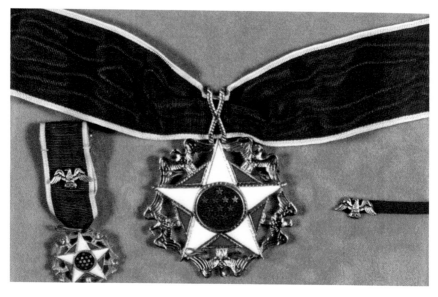

The Presidential Medal of Freedom. Dr. García was the first Mexican American to receive the highest honor presented to a civilian. *Author's collection.*

release of the poll results, President Kennedy created the Presidential Medal of Freedom.

Kennedy announced the first thirty-one recipients on July 4, 1963. However, Kennedy never got the chance to present the medals. The first presentation was scheduled for December 6, 1963, but Kennedy was assassinated just weeks earlier. Fourteen days after Kennedy's death, it fell to newly inaugurated president Lyndon Johnson to bestow the awards on American icons.

The medal is awarded annually as chosen by the president. Recipients are selected by the president, either on his or her initiative or based on recommendations. It may be awarded to non-U.S. citizens and may be awarded more than once or posthumously. So, when I received the call in 1984 from my father that he was going to be a recipient of the Presidential Medal of Freedom from President Ronald Reagan, I was absolutely stunned.

Papa was calm and very collected in our discussion; however, I could sense and hear the pride and excitement in his voice. This would be a historic moment for us. It certainly represented a lifetime of achievement and dedication to his country but also reflected his standing as a role model, patriot and leader. No one was more deserving than my father. He certainly fit the criteria for the medal, but the surprise was also due to the fact that after thirty-five years of sacrifices, he was finally being recognized at the highest level.

There were certainly some complainers and detractors. In 1984, I hoped that my father's life would be recognized by everyone as deserving of such an award. There were some who said that my father had only lived his life for this moment, to receive recognition. They did not really know this man. Some detractors from Three Rivers, Texas, have stated that my father lied about the Felix Longoria affair in 1948 to eventually be a recipient of the medal. However, the medal was not a valid award in 1948 for my father, as it was only awarded to honor service in World War II.

If you did not know my father, it would be difficult to accept that there was a man who existed for others. His service to this country, the poor and those who needed medical care stemmed from values that were taught to him at a very early age by his father, Jose. He was raised to be a servant to others. His early family life with his siblings taught him the value of philanthropy and "love of humanity." His life truly was reflective of his love of others, as was evident in his lifetime work in healthcare, veterans' rights, civil rights and education.

The telephone rang at 6:00 a.m. on March 26, 1984, in Washington, D.C., in my hotel room. After traveling to the capital the previous day from San Antonio, Texas, my husband, Jim, and I were certainly still asleep at

6:00 a.m. The medal presentation was not until 11:00 a.m. in the White House for lunch. On the other end was my father, of course. I said hello, which was a typical response when the telephone rings. The voice on the other side did not even say hello in return but instead yelled, "Don't leave the hotel for anything!" I could tell that he was very animated, nervous and excited. I do not know why he would think we would go anywhere without him. Certainly shopping was not on the agenda.

We wore our best business suits to the White House. My mother, Wanda, looked beautiful that day. We saw many notables at the White House, including Vice President George H.W. Bush, Senator Edward Kennedy, Eunice Shriver, Maria Shriver and Dr. Denton Cooley, who offered me a position as a physical therapist in Houston, Texas.

My father sat at the same table with President Reagan for lunch. I kept looking at him and was amazed at his demeanor. I knew that he had been to the White House on numerous occasions. But this time was very different for him. He was the one being honored, and I am certain that to receive the highest civilian award from a Republican president of the United States was beyond his wildest imagination. I noticed that he listened intently to the president and smiled several times. He was humbled by President Reagan's presence and the reception of such an award.

As the honorees all went on stage, President Reagan introduced each recipient and spoke briefly about them. When it came to my father, I felt President Reagan's voice softened as he called out the name of my father for his award: "Dr. Héctor P. García: Over the years, he has faithfully represented our government on numerous occasions overseas and domestically. Dr. Héctor García was a credit to his family, country and to all Americans. Through his efforts based on a deep belief of traditional American ideals, he has made this a better country."

My father was the first Mexican American to receive the Presidential Medal of Freedom. Historically, this was the first time that a Mexican immigrant would be recognized for a lifetime of service with the highest civilian award that existed. His accomplishments and sacrifices benefitted all Americans, and at seventy years of age, he was being honored by the president of the United States. It was a remarkable event to see my father humbled and happy but never forgetting where he had come from and what he had done to receive this recognition.

In that brief moment on the White House stage with President Reagan, my father mentally recalled his struggles, his perseverance and his love for America. After all, he had achieved the American Dream. His success

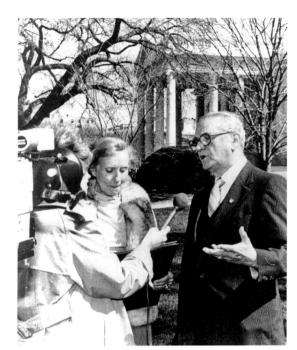

Right: Dr. García's news conference, White House lawn, March 26, 1984, after receiving the Presidential Medal of Freedom from President Reagan. *Author's collection.*

Below: Dr. Héctor and Wanda García at the White House lawn displaying the Presidential Medal of Freedom. *Author's collection.*

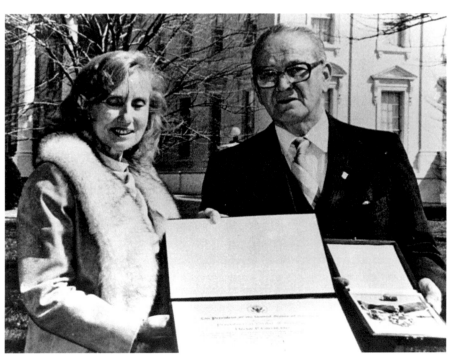

Left: Dr. Héctor and Wanda after receiving the Presidential Medal of Freedom. *Author's collection.*

Below, left to right: Senator Bentsen's Office in Washington, D.C., with Jim and Cecilia Akers, Senator Bentsen, Wanda and Dr. García and Daisy and Susie García after the medal presentation. *Author's collection.*

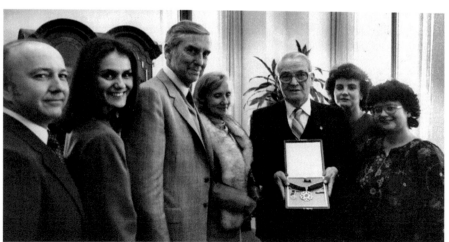

To Cecilia and Jim Ackers
with congratulations to a most
handsome and distinguished family
Lloyd Bentsen

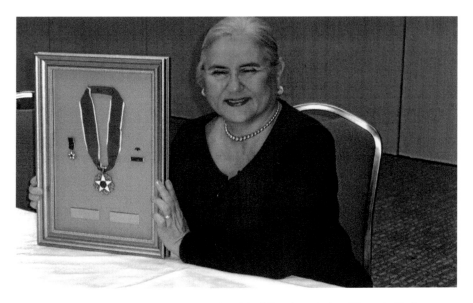

Cecilia García Akers with the Presidential Medal of Freedom during Hispanic Heritage Month Celebration at Creighton University, Omaha, Nebraska, 2014. *Author's collection.*

had come at a price, however. The price was sacrifices he had made personally, financially and emotionally to be recognized for a lifetime of service in a distinguished career. He definitely had achieved just what the medal embodied.

This Medal of Freedom award did not change Dr. Héctor. He was the same man, husband and father as before. He did, however, wear the medal everywhere he went. He wore it to every event, restaurant and dinner that he would attend. The medal meant the most to him over all the other recognition he had received. His pride came from being recognized for what he had done for all Americans, as well as the feeling of knowing that through his efforts, he had indeed made this a better country. My father did not halt his efforts after receiving the Medal of Freedom. He advocated for two new causes that would dominate his efforts until 1996: the fight against the "English-only" movement and the exposing of the substandard conditions of the *colonias* that existed on the Texas-Mexico border.

Indeed, my father felt that his mission on this earth had not been completed. There was more work for him to do. The Presidential Medal of Freedom was an award and recognition for what he had done. But he knew that there were other issues to address, and he would address them valiantly.

Chapter 9

THE TRANSFORMATION OF
A FATHER'S LOVE

As Dr. Héctor grew older, he continued to prioritize veterans' issues, civil rights and healthcare, but he also began to become more aware of the needs of his wife and family. In a person's life, time seems to fly by, life hurries along and our priorities change as we become older and wiser.

At the age of sixty-five, my father began to miss time with his children. By the time he was seventy, his three daughters were all grown up and had their own families and careers. They were independent, just as he had taught them to be. He had supervised his daughters' education and attendance at school and ensured that they would all finish their college education with degrees.

Daisy García achieved a bachelor's degree in zoology from the University of Texas–Austin, Susie García completed a doctorate in musical arts in piano performance and literature from the University of Texas–Austin and I graduated with a bachelor's degree from the University of Texas Medical Branch–Galveston in physical therapy.

We all had our own careers. None of his daughters would stay in Corpus Christi, Texas, though. Daisy García settled in Austin, Texas, and Susie García in Lafayette, Louisiana. I married and moved to San Antonio, Texas. We were all within safe traveling distance to Corpus Christi, and I would travel there as much as I could.

My father and I began calling each other daily. He loved watching the San Antonio Spurs, Dallas Cowboys and the University of Texas Longhorns

Dr. Héctor and the author at her wedding, January 28, 1978, in Corpus Christi. *Gold's Photography.*

play on television. His life became simpler in that he seemed to enjoy many of the things he had missed before because of his hectic schedule. When we were in Corpus Christi, my husband, Jimmy, would sit and watch sports on the television with him.

My father and mother attended many Nueces County Medical Society benefits and dinners together. They increased their time together and went out to eat very often. My mother was happy about the changes she

witnessed—more time with the family and, particularly, with her. My father seemed to have a better balance in his life. He also spent some Saturday nights at his office playing dominoes with his friends. As he put it, they would "play for quarters, and I would always win the most quarters."

If my father liked someone, there was no doubt about it. He would tease that person unmercifully. Bringing out a person's faults, in my father's eyes, was always comical. If he did not know a person's faults, he would make some up. His colleagues and physicians always seemed to enjoy his humor and his company. He also had nicknames for everyone, including my sisters. Daisy García was "curly top number one," and Susie García was "curly top number two." Since I always had straight hair, I did not get to share in these nicknames.

Top: Wanda, Cecilia and Dr. Héctor at Cecilia's wedding. *Gold's Photography.*

Left: Cecilia García Akers, director of rehabilitative services, Humana Hospital, 1986. *Author's collection.*

Above: Daughter Daisy García at work in Austin, Texas. *Author's collection.*

Right: Dr. Susie García and William Chapman Nyaho, Piano Duo. *Courtesy Susie García, photographer Blaine Faul.*

All my father ever called me was "Adriana," as that was the name he had given me at birth. He was the only person who called me that.

My father would try to pressure me to come home more often. I was the closest to him, so he really loved to see me and Jimmy come home. When I was there, he would buy loads of food, beer, snacks and ice cream. He loved to make a "Big Red Float." When his doctor advised him to lower his sugar intake, it then became a "Diet Big Red Float."

My mother was also a big fan of ice cream. He would buy a black cherry and vanilla carton, and she would eat the cherries and ice cream from the bottom of the carton, attempting to avoid his scrutiny and teasing. He would find out, though, when he tried to have a bowl of ice cream, as the spoon would only skim the top of the carton. The carton had a hollow bottom. He learned quickly what she was doing and would just go and buy more ice cream for her.

Jimmy and I would take my parents out to eat every time we would visit. My father would never allow Jimmy to pay the bill. At times, they would outsmart each other, with the waiter's assistance. We ended up with the bill maybe 20 percent of the time. My father could never relinquish his role as provider and father of his family.

Another example was when we would visit my parents in Corpus Christi, my father would always insist in giving me a twenty-dollar bill for gasoline. Jimmy would always refuse the money. So, my father would take me aside away from Jimmy, hand me a twenty-dollar bill and say to me, "Don't tell Jimmy I gave this to you." It was a game of outsmarting the son-in-law. I would tell my father, "Don't worry, Papa, I won't tell him about the money." He thought that it was our secret.

He seemed to enjoy life more. He had more down time. His American GI Forum traveling slowed down after 1988. He had some illnesses that needed attention. My parents enjoyed coming to San Antonio and even attended the wedding of our daughter, Melina, in 1995, even though it was a tremendous sacrifice for them to travel.

He was more attentive to my mother on a daily basis. He made the effort to be a better partner and provider for her. Their love for each other always was apparent in my eyes. Their love would endure forever. Their marriage lasted more than fifty years. Even though they would no longer be together in 1996 after his death, my mother would remain devoted to him until her own death in 2008.

My father's medical practice would constantly shift. He was no longer doing emergency room visits or surgeries, and he referred out to specialists

as much as possible. He continued with his medical office practice, but the urgent cases were passed on to someone else. He would have more time for leisure activities; however, his children were scattered away from home.

The holidays were very special, though. We would all come home for Thanksgiving and Christmas. My mother would cook a tremendous meal for her family. Jimmy and my father would watch football all day long, especially when the University of Texas and Texas A&M would play on Thanksgiving Day. My father really enjoyed opening his presents at Christmas. We could never fool him. He would guess every present we gave him, even down to the color! I don't know how he was so accurate, but he was always right. Many times people would come visit him and bring gifts, particularly food and many sweets. We always enjoyed these holidays.

When it was time to say goodbye after the holidays, I know my father became depressed. He would always ask me to stay a little longer or stay one more day with him. It was heartbreaking to hear him ask the question. We tried our best to stay as long as we could, and Jimmy and I went to Corpus Christi very often to visit my parents. My father had grown to love Jimmy, and they spent many hours together while my mother and I went shopping. Every trip to Corpus Christi was a joy to my parents and to us.

Dr. Héctor opening Christmas presents at home with Wanda and Susie García. *Author's collection.*

Nell Hahn and Susie García at Christmas at the García home in Corpus Christi, circa 1990. *Author's collection.*

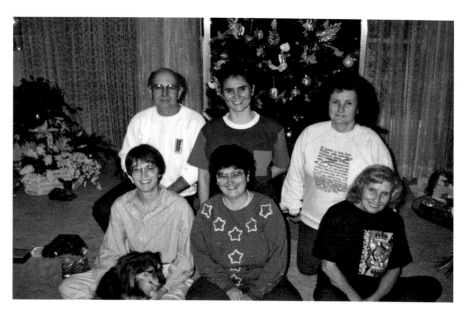

García family at Christmas. *Left to right, back row*: Jim and Cecilia García Akers and Daisy García. *Left to right, front row*: Nell Hahn, Susie García and Wanda García, 1992. *Author's collection.*

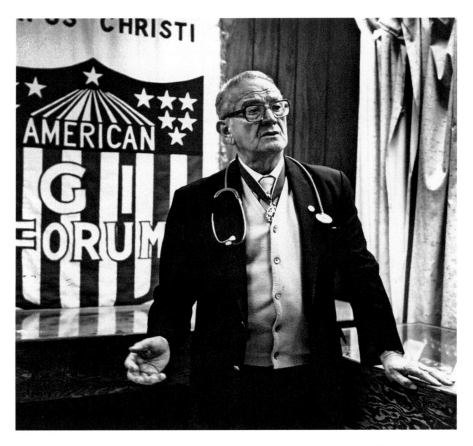

Dr. Héctor P. García, physician, statesman and founder of the American GI Forum. *García Papers, Special Collections and Archives, Bell Library, Texas A&M University–Corpus Christi.*

As my father became older, he would want to go on long rides around Mustang Island and over the Harbor Bridge. Jimmy was a good driver, and Papa trusted him with his Cadillac. The music blared loudly during these rides.

One can only imagine the sacrifices a family of such a noted civil rights leader must make in order for them to be successful. Additionally, my father's medical practice was very demanding, but he wanted to support his family the best way possible. The family really has to support and make the sacrifices for the success of the cause. My mother had two roles, not only as the matriarch but also, in many ways, as the father as well. She quietly supported and loved my father, and his children loved him and defended all of his actions. We just would not have it any other way.

Over the years, time became more precious to him, and my father became more dependent on his family and others. He had grown as a person who appreciated the time with his family, yet I know that toward the end of his life, he truly missed the years seeing his children growing up. He was regretful of that loss of time that he could never recover. My father had finally realized the love that he had for his wife and family. He knew that he had accomplished much in his life by helping others and changing the direction of the country, but somehow he also knew that he had forever lost precious time with his family as well.

WANDA FUSILLO GARCÍA

Wanda Fusillo was born in Caserta, Italy, on November 15, 1919, to Angelo and Aida Fusillo. Wanda was the eldest of four children and the only woman. Her brothers were named Manrico, Giuseppe and Ruggero Fusillo.

All of the Fusillo children were highly educated and took on professional careers. Manrico was a chemical engineer and worked for Mobil Oil until his death. Giuseppe was a naval engineer and built large ships, and Ruggero was an attorney and worked in public administration. Wanda would outlast all of her siblings. Manrico died after being diagnosed with a neurological disorder. Giuseppe, a very heavy smoker, died from lung cancer, and Ruggero died in a tragic car accident when he was quite young.

The Fusillo family had high expectations for all of their children. Wanda achieved a doctorate in the humanities from the University of Naples on June 30, 1944. Her thesis was on *Virgil's Aeneid, Book II*. The manuscript is in Italian and well preserved. Wanda, remarkably, completed her thesis during World War II, which proved her commitment and determination to complete her education. Wanda worked during the war to support her family. Her father, Angelo, had passed away earlier, and the hardships of war were difficult for the entire family.[33]

Wanda had a job as a secretary at the port authority in Naples, Italy. She was proficient in English and had excellent typing skills. She was respectful of and polite to everyone she encountered and took much pride in her work.

Wanda Fusillo in Naples, Italy, 1945. *Author's collection.*

A friend of Wanda's knew some American soldiers who were stationed in Naples, Italy. One of these soldiers was Captain Héctor P. García. Now Captain García was intelligent, determined and knew exactly how to impress others. He had been researching the Italian general, author and conqueror Giuseppe Garibaldi. Captain García was well versed in five languages: English, Spanish, Italian, German and some Arabic. He was able to assimilate into many cultures by speaking their language.

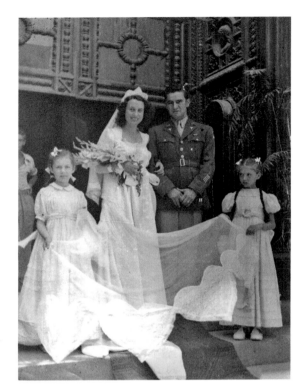

Right: Dr. Héctor and Wanda García at their wedding in Naples, Italy, June 23, 1945. *Author's collection.*

Below: Dr. Héctor and Wanda in their honeymoon military Jeep in Naples, Italy, during World War II, 1945. *Author's collection.*

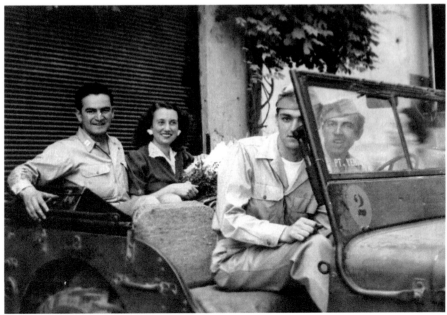

Besides Héctor's good looks and charm, he had the ability to fascinate you with his personality, knowledge of various subjects and his sense of humor. He also never took no for an answer. This is exactly how he enticed Wanda into their first date. Soon after meeting, Captain Héctor and Wanda began spending time together. His first gift to her, as she recalled the story, was a rosary. Wanda and her family were devout Catholics. Wanda was very loyal to the Catholic Church and never missed a Sunday Mass throughout her life. She always said that after meeting my father "he never left me alone." Trying to impress not only Wanda but also her mother and brothers, he would take supplies, cigarettes and food to them in a U.S. Army ambulance. Captain Héctor knew how to engage everyone in his schemes—this one would be to marry Wanda Fusillo, as he had already made the decision himself. Wanda would find out about it later.

Captain García left for Germany. Wanda thought Héctor would forget about her and not return. However, Héctor managed to obtain a marriage license, arrange a wedding and invite as many people as he could to attend. Wanda was very surprised at his ability to get things arranged. They had a beautiful wedding and were married in Naples, Italy, on June 23, 1945. I remember viewing her wedding pictures when I was younger and thinking how beautiful she looked and how handsome my father was. I also remember that there were two flower girls attending my mother. I was a little upset that I was not included in the photo, and I innocently asked her, "How come I was not at the wedding?" My mother smiled and tried to explain to me that I had not been born yet.

Wanda stayed in Italy and had their first child, Daisy, in June 1946. My father separated from the army on March 1, 1946, but did not receive his U.S. citizenship until November 7, 1946. I am certain the delay in bringing Wanda and Daisy García to the United States was caused in part by the delay in my father obtaining his citizenship.[34]

Wanda's family tried to convince my father to stay in Italy to practice medicine. He would do well there. However, Dr. Héctor stated that he had to return to Texas because he had a mission. Wanda arrived in Corpus Christi, Texas, in 1947. She could never imagine what she would encounter very far away from Naples, Italy.

My mother was always very supportive of my father's advocacy and involvement in his activities since her arrival in this country. Wanda was the only person Dr. Héctor would listen to, and he heeded her advice. They would have morning coffee together and discuss the headlines of

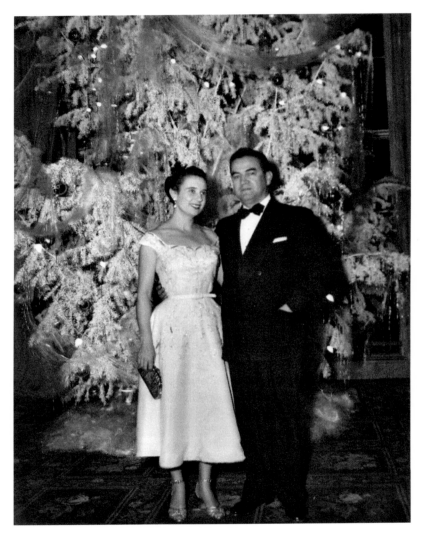

Dr. Héctor and Wanda García at a Nueces County Medical Society Christmas party, Driscoll Hotel, Corpus Christi, circa 1950. *Author's collection.*

the day. He respected her political views; she was the only person who could disagree with him, and he would listen to her viewpoints.

My father founded the American GI Forum on March 26, 1948, in Corpus Christi, Texas, as a veterans' family organization at Lamar Elementary. In the early years, Wanda would travel with Dr. Héctor for American GI Forum organizing and attending meetings. She was the

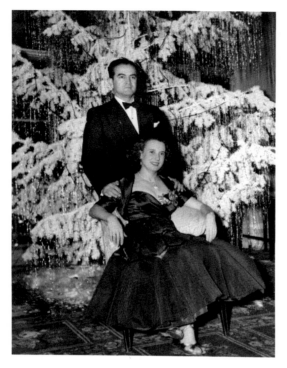

forum's first secretary but always would be the only "First Lady" the American GI Forum would have.

As their family grew, Wanda was unable to continue helping her husband. Héctor García Jr. was born on July 23, 1948, followed by my birth in 1952 and Susie García in 1956. They would have four children, with each needing care, attention, a proper education and supervision. As the children grew, my father was frequently absent for many days, organizing and traveling throughout the country. In addition, his medical practice was overwhelming at times, with high volumes of office visits, hospital rounds, ER visits and some house calls. Quality time for Wanda with her husband was very limited. She learned early

Top: Dr. Héctor and Wanda García celebrating Christmas at the Driscoll Hotel, Corpus Christi, circa 1950. *Author's collection.*

Left: Wanda García at Nueces County Medical Society dinner, Corpus Christi. *Author's collection.*

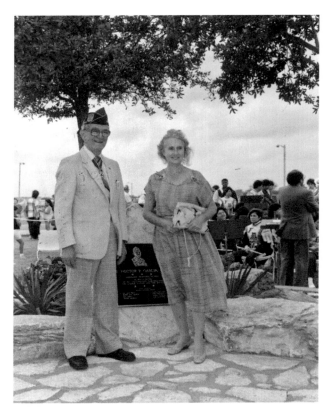

Right: Dr. Héctor and Wanda García during the dedication of the Dr. Héctor P. García Park in Corpus Christi, November 10, 1985. *Author's collection.*

Below: Jim and Cecilia García Akers and Wanda and Dr. García at Governor Ann Richards's inauguration, January 15, 1991, in Austin, Texas. *Author's collection.*

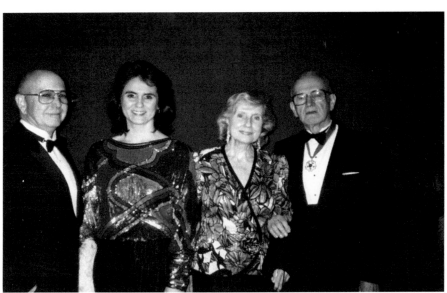

on that she would have to share her beloved husband with others, financially and personally.

Young Héctor's passing in 1962 was a devastating loss to the family, especially to Dr. Héctor and Wanda. I never knew how they managed to recover, but their Catholic faith and their love for each other and understanding of their responsibilities to their other children pulled them through. Life would go on. Dr. Héctor would begin pioneering his civil rights work on the national stage, expand his medical practice to a new clinic and promote education to young American GI Forum members.

Wanda became a little more isolated and withdrawn from the public after Sonny's death. She channeled her efforts into her home, faith and family, yet she continued to advise my father about his efforts to improve this country for all Americans. She understood that my father had a mission to fulfill, and she would have to hold the family together to help him accomplish that mission. Wanda did enjoy the simple things of life. She was an accomplished gardener and loved going shopping, watching soap operas and eating ice cream. She did read and loved her books when she had some free time. Their home library had expansive collections of literature, historical books, encyclopedias and novels.

Wanda was a very strict mother with her children. The death of Héctor Jr. caused her to become overly protective of her family. Every friend and

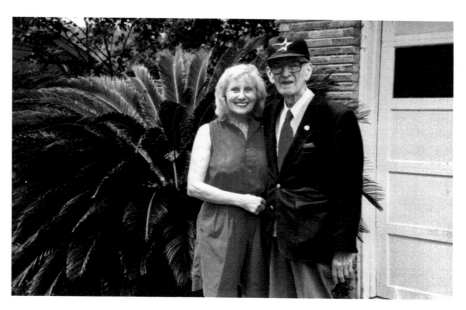

Wanda and Dr. García at their home in Corpus Christi, 1994. *Author's collection.*

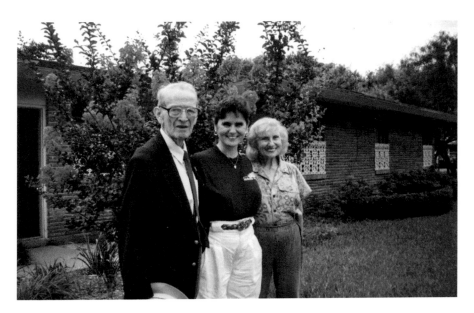

Dr. Héctor, Cecilia and Wanda at home in their backyard, Corpus Christi, 1994. *Author's collection.*

acquaintance was scrutinized by my father and by Wanda. She always feared the loss of another child, due to my father's high-profile work. There were many threats made toward her and her children. She even worried about our pets. Wanda also wanted her daughters to be educated, as well as to look a certain way and act dignified at all times. We were definitely under a microscope in Corpus Christi. We were a reflection of her style, as she was really the one responsible for raising the family. She made sure that our homework was done on time, that we would go to school as scheduled and that we would make the best grades possible. The sisters who educated us at St. Patrick's Catholic School and Incarnate Word Academy treated us as college-bound. We were prepared at a higher educational level than most. We were expected to do well.

Wanda was always shocked by the behavior of others toward Dr. Héctor and her family. Having moved to a very nice upscale "white" neighborhood, she witnessed many challenges. She learned to accept that this hatred toward her family was a part of life. She loved her husband for who he was, what he stood for and his compassion for others.

Wanda would never waver in her love for my father. I know that at times she expressed some anger, regret and remorse for coming to Corpus Christi, Texas, giving up her aristocratic life and closeness with her family.

She would only see her family in Italy two more times. She did not like to fly by airplane, even though it was a safe way to travel. My father always encouraged her to go to Italy, but she would not leave home and did not want to leave him alone.

Their life blossomed in their later years. My father had a booming medical practice, his efforts had been very successful on a national level and he was awarded many honors, including the highest civilian award, the Presidential Medal of Freedom in 1984. Wanda did her best in maintaining their home. She accompanied her husband to all his events. His daughters also were supportive of his work.

Toward the end of his life, Dr. Héctor became ill and frail. He closed his medical practice in March 1996. An era of healthcare for thousands of people and the impoverished had come to an end. My father struggled in the last months of his life. Unable to eat, he had to use feeding tubes constantly. My mother went every day to visit him. Always hoping for the best, she would call me daily to confer. I quit my full-time job in May 1996 to assist them both. I was happy to direct his medical care, as it was necessary to ensure his comfort. My mother was grateful for my assistance. She was overwhelmed with the responsibilities, seeking comfort from me and trying to maintain her own life. His medical complications would become more severe for him. His condition deteriorated slowly but surely. My mother was preparing for life without her beloved husband.

On July 26, 1996, Dr. Héctor P. García passed away to eternal life. He had pneumonia and congestive heart failure and died at his beloved Memorial Hospital, where he had practiced medicine for more than fifty years. In the next few years, Wanda tried to maintain their large home in Corpus Christi, Texas. It was difficult, as their home started deteriorating, was filled with mold and needed major repairs. Wanda's health also started declining, and she needed major surgeries.

I moved my mother to San Antonio, Texas, in 2002. I managed to set her up with the best physicians I knew. We managed six surgeries in the first two years in San Antonio. Wanda lived with me for one year; all in all, it was a serious challenge, but we had many good times together. My husband, Jimmy, was left to handle the major transportation of my mother to her appointments. He moved her three different times. We finally settled on an upscale senior living complex.

Ms. Wanda had a personal fitness trainer, a chauffeur, the best medical care available, transportation in a limo and the ability to enjoy the rest of her days on her own terms and with full contentment of her life. She was no

Vice President Al Gore congratulating Wanda García, widow of Dr. Héctor García, at the announcement of the seventy-five-dollar I-Bond with Dr. García's picture, July 8, 1998. *White House Photo.*

Cecilia García Akers and Wanda García unveil the sign designating the portion of Crosstown Expressway to be named the Dr. Héctor P. García Memorial Highway, April 9, 2008. *Michael Zamora/*Corpus Christi Caller Times.

Cecilia García Akers and Wanda García at highway dedication renaming a section of Crosstown Freeway Dr. Héctor P. García Memorial Highway, in Corpus Christi, April 9, 2008. *Michael Zamora/*Corpus Christi Times.

longer worried about finances, as Jimmy and I took care of her financially. She had no worries, was well taken care of and was truly happy.

Ms. Wanda, as we all called her in her later years, began to worry about her husband's legacy. One afternoon, I received a phone call from her. She was weeping and asked for me and Jimmy to come over. When we arrived, she produced the latest issue of the *Forumeer*, the quarterly magazine of the American GI Forum. The March edition (the "Founder's Month") did not have one photograph of Dr. Héctor or even any mention of him. She was crying uncontrollably. She told me how no one knew who Dr. Héctor P. García was or his sacrifices or accomplishments. Even the American GI Forum had forgotten about him, she felt. On that date, Jimmy and I made a promise to her. We promised that we would dedicate the rest of our lives to ensure that her husband would be known and taught in schools and universities and that his life would be celebrated. Their sacrifices would not be wasted, as there were so many people who loved him and appreciated his work.

Toward the end, Wanda's life began to transform. She lost weight and could not eat, and her behavior changed. I did my best by arranging in-

home physical therapy, nursing, occupational therapy and doctor's visits. I became her advocate while she was hospitalized. I fought her battles for her and ensured that she received proper care. It was a devastating reality to make sure your mother received the care that she deserved. Our roles in life had reversed. I had become the parent. My sister Susie García and her partner, Nell Hahn, came to my assistance immediately. We struggled with the final decisions regarding our mother's care. I called a priest in to see her for her last rites. We were able to fulfill her wishes. Susie was able to be more objective about these matters than I could be.

On September 20, 2008, the matriarch of the García family passed into eternal life. I was blessed and honored to care for her for the last six years of her life. I thank God and pray to her daily for strength. I was able to give back to her for all the years she put up with me. Her struggles when moving to this country; her love for her husband, family and church; and her sacrifices throughout her life were often overlooked. Also, the horrors of World War II and dealing with the constant hatred toward her husband were difficult for her to accept. She battled loneliness with determination, but she had a very public life. The death of her only son and then later her husband weighed on her emotionally. A very strong personality, she understood her role as a wife and mother but also as the partner of the greatest Mexican American leader of this century.

I will never forget the last time I talked to her. In her hospital bed, she had constant care and attention. While leaving her room for the night, I always blew her a kiss and said, "I love you, Mamma." She always blew back her kiss to me and would smile. I was grateful that she died peacefully in her sleep. Indeed, God had taken good care of Ms. Wanda.

THE END OF AN ERA IN MEXICAN AMERICAN HISTORY AND CIVIL RIGHTS

Dr. Héctor P. García's lifelong advocacy affected this country in many ways. I always like to state that he "changed the face of America." He had a vision early on, the promise of America for every race, nationality and creed. However, his experiences in his life told a very different story—that the promise of America was not for "everyone."

My father faced many battles throughout his life. He faced each of them with courage, integrity and determination. His family was not aware of many of the personal stories of how he helped others until after his death. He never came home and related his successes or honors to his family. I think, in part, he was never satisfied with his accomplishments. There was always more to do, more changes to come and more legislation to have enacted. His journey was never going to end, not in his lifetime. This country needed a leader to correct the wrongs and help the disenfranchised.

Throughout Dr. Héctor's younger days and even well into his seventies, he was valiant and energized and was able to put in eighteen to twenty hours per day for his medical practice and advocacy. Things started to change for him in the late 1980s. He had a myocardial infarction due to three blocked cardiac arteries, which necessitated open-heart surgery. He lost a significant amount of weight, underwent a cardiac rehabilitation program and recovered in order to resume his previous workload. He was remarkable. He had the tremendous support from his brother Dr. Xico García and his sister Dr. Cleo García, who would cover his medical practice for him. They kept his income fluid and kept his patients returning to his office for further care.

García family posing under a mural depicting Dr. García's life, circa 1990. *Author's collection.*

My parents were dependent on their assistance. They provided intermediate coverage as long as Dr. Héctor needed it.

His illnesses reoccurred sporadically, and they were devastating to him, physically and emotionally. They reminded him of his own mortality and that he would be dependent on others for assistance and advice. As my father became older, he had increased difficulty recovering from his illnesses. I felt

that he did not plan well for this stage of his life. Money was always scarce for him and Wanda. He was not good at maintaining a savings account, and they did not trust the stock market enough to invest. He always gave me the impression that he thought he could work forever. I know that he never wanted to retire from his medical practice; he just could not see himself in any role other than that of a physician.

He was afforded a wonderful opportunity, though. His friends and President Dr. Robert Ferguson at Texas A&M University–Corpus Christi had big plans for his legacy. As Dr. Héctor had donated his papers and memorabilia in 1990, the university was hopeful to have him as a faculty member. It planned to have him lecture regularly, pay him a salary and provide him an office and a secretary. He would have everything he needed. He was also offered the opportunity to have a Mexican American physician to cover his practice when he lectured.

My father had extreme difficulty altering his role from physician to professor. We had several discussions about this transition. The university was making it a very easy process for him. It was accommodating and provided him an adequate salary and all the assistance he would need. The university and I thought that any student who would have the opportunity to hear my father lecture about his work in civil rights and the history of this country would be fortunate to have these experiences. His personal perspective on all of his struggles would provide students some wonderful lessons and give them unique insights into this country's evolution since World War II.

This plan would also relieve him of the rigors of his medical practice, ER visits and hospital rounds. I thought that the stress of his medical practice would be passed on to the new practicing physician and that my father would be free to research, write his lesson plans and lecture. He would be a professor in the history department. It was a dream come true, except not for my father. He would ultimately decline the offer, stating, "I just cannot think of doing anything else." That was his final decision. I thought it was not a very wise one, as he was not thinking of his future. I feel he was hoping he could continue as he always had. However, time would not be on his side.

My father soon began to have some more serious issues with his health. He would recover and return to work as best as he could. He believed his work was not finished, as there was always someone needing medical care or assistance with a problem. He was not satisfied with the conditions that his people faced.

During one of his illnesses while admitted to the hospital, he was inspired by a "visitor." This visitor dressed in a brown robe with a hood and entered

his room with a rosary in his hand. My father always had a "no visitors" sign on his door, and the nurses were strict with the hospital's policy. The visitors were limited to keep distractions to his healing at a minimum. This visitor told my father that "your work on this earth is not finished." The visitor then quietly left my father's room. No one else had seen this visitor—just my father. This was the inspiration he needed to continue his advocacy, even though my father was older and had some health issues.

Dr. Héctor struggled in the last years of his life. He tried to maintain a medical practice, perform at the highest level as the founder of the American GI Forum, continue organizing chapters and be a husband and father. This would prove to be difficult, as he could not relinquish any of the things that he had been involved in all of his life. He was a true warrior—the Trojan prince of Greek mythology, and the greatest fighter for Troy, proved to be accurate as a model. He was a warrior and fighter for his patients, veterans and all of his people, including the poor and uneducated. Héctor was the perfect name for him, and he would live up to this symbol, even toward the end of his life.

The most devastating diagnosis came to my father around 1994. He had stomach cancer and needed surgery to remove the tumor. The surgeon removed half of his stomach. Everyone was hopeful, and the outlook was positive. There was no reoccurrence of stomach cancer following an endoscopy six months later. He was free of cancer. However, the recovery was slow and complicated. My father had convinced himself that the physicians made a mistake or they were not being truthful with him. He became somewhat confused and did not want to eat any longer. Since his father, Jose, had died from stomach cancer, Dr. Héctor persuaded himself and others that this was also going to be his demise.

The weight was falling off him rapidly. We spent our last Christmas together in Peerman Place in December 1995. I noticed that my father had become depressed about his condition. His patient load had dropped, and he was unable to work the long hours to which he was accustomed. He became weaker and lost his vitality for life, struggling more and more. Finances were tight, as my parents were living on their Social Security checks. His referrals at his medical practice had dried up. He did have some bonds that he could cash in for income, but he had not truly prepared for this aspect of his life. He also was stubborn and would not listen to advice from his friends or family, nor would he accept monetary assistance.

My father had done well financially with his medical practice. His problems occurred through his continuous monetary support of the American GI Forum, including travel, conventions and other expenses. He

never reimbursed himself for his personal expenses. His two greatest assets, his home and his medical office, were left in his will to my mother, Wanda. My mother would have to sell his medical office as soon as possible for income. She sold it in the year 2002 to the National Archives and Historical Foundation of the American GI Forum. My father's former office continues to exist in a deplorable state to this day.

As time progressed, my father's condition deteriorated. He entered Memorial Hospital for the last time in February 1996. As he was unable to eat and barely walking, we had to take immediate action to help him. My uncle Dr. Xico García assisted my father's personal physician with his care. Dr. Xico visited my father several times a day and made sure that he was taken care of as he should be. His medications were checked, and every treatment was monitored. My father trusted his brother and was appreciative of his intervention in his care. My father received a feeding tube and IV fluids. I tried to walk him as much as I could. His mobility was very limited, though, and sometimes he was in pain. He would try his best, but somehow every approach would be futile.

Dr. Xico García organized and established a vigil of his followers and supporters, twenty-four hours a day, seven days a week. These people who loved him stayed with him day and night and tended to his every need. Most noteworthy were Agnes Horn, Jose Ronje, Willie Davila, Gilbert Oropez, Jose Espinoza, Jose Ramos Sr., Haas Ivy, Jessie Soto, Martin Barrios, Jesse Escobedo, Robert Salinas and Mel Ynostroza. They were giving back to him for all the years he had given them with his support and advocacy. Sadly, most of these fellow warriors have passed on also.

With the change in my father's condition, my mother made the decision to close his office. She could not continue with the monthly expenses of utilities and upkeep. The office was closed on March 29, 1996. All of my father's belongings remained in his closed office until after his death. After my mother shuttered my father's office, it was the beginning of the end for him. Realizing that he could never return to his medical practice, he totally gave up mentally and emotionally. He felt that there was nothing left for him in his life because his medical practice was gone. Fifty years of helping and healing his patients had come to an end.

Even though he had accomplished much in his life, he viewed his life as a failure because he felt that he had so much more to do. I remember trying to comfort him in his final days and reminding him of all the hundreds of thousands of people he had helped medically and improved the lives of others whom he had never met.

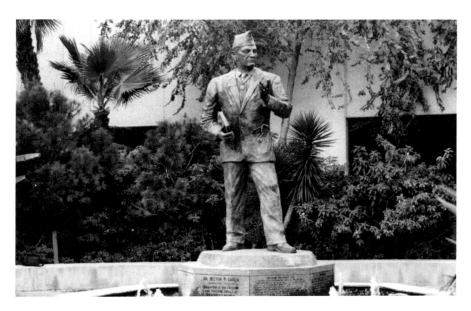

A nine-foot bronze statue of Dr. García that stands in the Dr. Héctor P. García Plaza, Texas A&M University–Corpus Christi, dedicated in June 1996. *Author's collection.*

There would be one great, historic moment for my father prior to his passing. In June 1996, a nine-foot-tall bronze statue was erected in the Dr. Héctor P. García Plaza at Texas A&M University–Corpus Christi. The funds for the statue and plaza came from private donors and businesses. My father took a ride out of the hospital to visit the plaza and was able to see the beautiful tribute to his life. Although he was touched by the outpouring of love and admiration for his work, he did not feel deserving of such an honor. However, that statue represented his contributions to this country for the public to view and for all the students to ponder and research. That statue would always be representative of an American hero who lived among us and who could never be replaced.

Dr. Héctor P. García passed away peacefully on July 26, 1996, of congestive heart failure and pneumonia at Memorial Hospital in Corpus Christi, Texas, the only hospital where he had practiced medicine. Although this was expected, I was still unprepared for the news. We planned a funeral fit for a king.

The García family came together. My cousin Tony Canales took the lead in the planning of the funeral. The funeral home discounted the services for my father. We were fortunate to have so many people wanting to help us. My father had helped the funeral home director on many occasions by sending

Wanda García, Cecilia García Akers, Daisy and Susie García and Nell Hahn at Dr. García's funeral, July 30, 1996. *Author's collection.*

to him many of the returning soldiers from Vietnam for a proper funeral and burial.

The wake was at the Selena Auditorium. Thousands of people filed by his closed casket, draped with an American flag. I felt that I had to speak to as many people as I could. I happened to find a group of elderly ladies all dressed in black, most using walkers, crying in a room by themselves. As I approached them, they spoke in Spanish that they were there because "he was my doctor." They had made the sacrifice to attend the wake to say goodbye to their doctor, the one who had cared for them for many years.

His funeral was well planned, beautiful and regal. A thousand people came to the Corpus Christi Cathedral to say their goodbyes. I was one of the speakers to eulogize my father, along with Dr. Xico García and Tony Canales. The trip to the cemetery was long and hot. The city had shut down for the procession. In a way, I did not want it to be over, as I had a problem telling my father goodbye for the last time. So many people were there. I had to speak to everyone. I felt as my father's daughter it was the least I could do. My father had full military honors, taps and a twenty-one-gun salute at his funeral. It was a fitting tribute to someone who had represented veterans for fifty years.

My mother was tired but gracious to everyone. She proudly accepted the folded United States flag that had draped his coffin "from a grateful nation."

There is one image from his funeral that I will never forget. During his procession to the cemetery, an Anglo man was standing outside on Ocean Drive, in the July heat, as the hearse was driving by. He saluted my father one last time. A final salute from an unknown person who had appreciated my father and his contributions to this country. A lifetime of service was recognized that day. We could not have asked for anything more fitting for him. Although his life was over, his legacy would remain. We learned later that there would never be another leader like Dr. Héctor P. García. He lived his life unselfishly and for others at tremendous personal sacrifice. He would never be replaced in our lifetime.

THE LEGACY CONTINUES

In 2004, a devastating phone call from my mother, Wanda, prompted me and my husband, Jimmy, to do some deep soul searching. My mother was very saddened and upset that her husband's efforts were not being acknowledged. Our conversations led us to an everlasting promise to her to secure my father's efforts and accomplishments and to ensure that his legacy would forever be recognized.

We realized that Dr. Héctor P. García did not have a proper place for his accomplishments historically. He was not being studied at any level other than third grade in the Texas curriculum. Also, the American GI Forum, the organization that Dr. Héctor founded, was not promoting or preserving Dr. Héctor in history. The organization's recent efforts were not aligned with Dr. Héctor's vision for veterans and education.

Our first efforts consisted of assisting the American GI Forum to realign its efforts with Dr. Héctor's. The organization no longer had national prominence, membership was falling and its financial support had declined substantially. Despite our efforts and the work of others to assist the organization, we were not successful.

We decided that my father's legacy was the responsibility of his family. I felt tremendous guilt that I had not recognized his importance much earlier. I thought that others would have his best interests at heart. I was wrong. I decided to forge my own efforts and started researching his contributions and impact to this country as a whole rather than just for Mexican Americans.

Cecilia García Akers speaking at a UTMB luncheon honoring her father. *Author's collection.*

Moses Estrada with Jim and Cecilia Akers at a Memorial Mass honoring Dr. Héctor García, Incarnate Word Chapel, Corpus Christi. *Rachel Denny Clow*/Corpus Christi Caller Times.

Texas A&M University–Corpus Christi ROTC Color Guard presenting colors at Dr. García's 100th Birthday Celebration, January 17, 2014. *Eddie Seal Photography.*

Politically, we would focus our efforts toward a Texas State Recognition Day. Our first attempt failed; however, we were able to educate members of the legislature about my father's contributions and were able to build on a concurrent resolution that was passed in 2007. We prepared for the next legislative session in 2009. The Texas legislature basically did not know who Dr. Héctor P. García was, much less understood the impact of his accomplishments to the state of Texas.

My mother was instrumental in selecting the date on which she wanted her husband honored, which was the third Wednesday of September, to start National Hispanic Heritage Month. We redirected our efforts for 2009 for successful passage of the bill.

Starting early, we secured our main sponsors. SB495, sponsored by Senator Juan Hinojosa from McAllen and State Representative Abel Herrero from Robstown, led the way. We had other sponsors sign on to the bill. We were pleased with the enthusiasm the bill was generating throughout the session. The main effort was educating the representatives, which entailed one-on-one meetings with each of them or their staff members. We had many influential people and organizations assisting us, including the University of Texas Medical Branch–Galveston, the *Corpus Christi Caller Times*, Texas A&M University–Corpus Christi and other individuals.

Keynote speaker Dr. Rebecca Saavedra, University of Texas Medical Branch–Galveston, addressing the Dr. Héctor P. García Birthday Luncheon, January 16, 2015. *Eddie Seal Photography.*

Dr. David Callender, president of the University Texas Medical Branch–Galveston, speaking at annual luncheon honoring Dr. García and scholarship presentation, 2014. *Author's collection.*

On May 18, 2009, SB495 passed the Texas House of Representatives and was signed by Governor Rick Perry on May 30, 2009. We were on our way. This was a historic accomplishment and would pave the way to educate schools and the public regarding the accomplishments of Dr. Héctor P. García, the hero who was among us in so many ways and the man who lived his whole life without seeking personal recognition ever. His legacy is deserving for all of us to know, understand and appreciate.

In October 2009, the Dr. Héctor P. García Middle School was dedicated in San Antonio, Texas. Three hundred names were submitted for that school, and Dr. Héctor's name was selected due to his advocacy in education. My cousin Gayle Arambula was the person who submitted my father's name for consideration to the Northside Independent School District. There have been five schools named after my father, located in Dallas, Grand Prairie, San Antonio and Temple, Texas, and Chicago, Illinois. Certainly, his devotion to education for all children has been recognized in not only Texas but also outside his home state.

The United States Army has recognized Major Héctor P. García as one of the most influential Hispanics who served in this branch of the military. His status is similar to that of other prominent Hispanics who achieved the rank of general. It is quite amazing for him to be recognized by the United States Army in this manner, given all the barriers he had encountered moving up the career ladder, as well as with commendations and promotions. He finally achieved the rank of major in 1947 after being discharged in 1946; he was already back in civilian life practicing medicine when his status was upgraded.

The failure of the Texas State Board of Education to include my father and other Hispanics in the public school curriculum reminded me of the days my father fought the Corpus Christi Independent School District against segregation. No honorable mention of Hispanic heroes was included in the lesson plans. Dr. Héctor was only included in the third-grade curriculum. In 2010, the Texas Board of Education made plans to upgrade its books. My husband, Jimmy, decided to take on that fight to have Dr. Héctor included at appropriate levels so that all students would be able to learn about his accomplishments.

This battle lasted six months and included testimony lasting until midnight, as well as having to withstand grueling questions from the board members regarding the need to have Dr. Héctor P. García in the public school curriculum. Somehow we prevailed. After three testimonies in Austin, Texas, it was finally decided that Dr. Héctor would be included in the "Must

Be Taught Section" in the third grade and seventh grade, as well as in high school U.S. history since the year 1877. A Hispanic historical figure would finally make it into the Texas curriculum through the efforts of someone who knew him best, his own son-in-law, Jimmy Akers.

Someone with such unique accomplishments was certainly deserving of more attention and recognition. Feeling personally responsible for my father's place in history, I decided with other family members and many community and elected officials to establish the Dr. Héctor P. García Memorial Foundation in 2012. The foundation would give us many future opportunities to promote Dr. Héctor as well as engage in the activities that he cherished and fought for in education and healthcare.

Why should we honor and remember Dr. Héctor P. García? We asked ourselves and others how we could preserve his legacy in the most effective way. One of the best things we could do is to finance students' education through scholarships at various educational institutions in Corpus Christi, Texas, that were willing to put Dr. Héctor at the forefront. The potential recipient would be required to do research and write an essay on the effects Dr. Héctor had on the student's life and education. We would be assured that this recipient would understand the benefits of a good education and the impact Dr. Héctor had on his or her life.

I felt that healthcare was my father's strongest influence on this country. Having worked by his side, I understood his primary care role as a physician. A wonderful opportunity arose to have his legacy remembered for many years to come. His compassion and understanding of people in need of assistance set him apart from all others.

When Christus Spohn Health inquired as to my willingness to name the first primary care facility in Corpus Christi, Texas, after my father, I could see no negatives in the plan. The old Memorial Hospital would have to be demolished to make the transformation of healthcare complete for the area. The excitement lies in the improvement of the delivery of services to an area of the city where long admission and ER wait times existed. This new facility would provide primary care services such as a pharmacy, nursing, radiology and physician services to all who would walk into those doors. For what we envisioned for good, basic services, my father would be pleased that his patients would receive the best care available. The facility, to be named the Dr. Héctor P. García Memorial Family Health Center, would be opened in 2016.

The Dr. Héctor P. García Memorial Foundation will continue to pursue appropriate and significant developments in Dr. Héctor García's memory. In

Dr. Elizabeth Protos, dean of UTMB; García Scholarship recipient Erynn Frenchak; and Jim and Cecilia García Akers at School of Health Professions Scholarship Luncheon, Galveston, Texas, 2013. *Author's collection.*

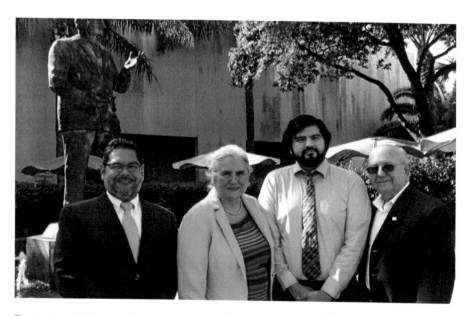

Dr. Anthony Quiroz of Texas A&M Corpus Christi, Cecilia García Akers, scholarship recipient Daniel Yzaguirre and Jim Akers, July 30, 2015. *Author's collection.*

2015, the foundation established an endowed scholarship named the Héctor P. García, MD, Endowed Presidential Scholarship in the School of Medicine at the University of Texas Medical Branch–Galveston. This scholarship memorializes one of the university's most distinguished alumni and provides needed financial assistance to one medical student from the Corpus Christi and Rio Grande Valley area per year. We are proud to be able to promote Dr. Héctor in this manner at the university that he loved so much.

The need is apparent for the Dr. Héctor P. García Learning Center at Texas A&M University–Corpus Christi. This will be a tremendous honor when completed. It will house more than seven hundred linear feet of documents and more than than five thousand photographs and showcase exhibits of historical artifacts and photographs. Finally there will be a permanent home to display, study and research his historical accomplishments. This is the primary goal for the foundation. How pleased my father would be that students were researching his causes that bettered our lives.

We can all enjoy our lives today because of the tireless work of my father. He was not a figurehead for his organization. He was a person who made changes in this country. How different would the United States of America be if that young soldier had not returned from World War II in 1946

Cecilia García Akers with cousin Tony Canales holding the street sign for Dr. Héctor P. García Drive, to be placed in a new subdivision by Braselton Homes, January 16, 2014. *Eddie Seal Photography.*

Cecilia García Akers addressing a luncheon honoring her father, September 17, 2008, at the American Bank Center, Corpus Christi. *George Gongora*/Corpus Christi Caller Times.

and recognized everything that needed to be changed for veterans and in civil rights and healthcare? Dr. Héctor P. García improved the lives of all Americans. As President Ronald Reagan stated on March 26, 1984, about Dr. Héctor García while awarding the Presidential Medal of Freedom, "His efforts had made this a better country."

We all must be responsible Americans. We must know and understand our Constitution and make sure that past atrocities against us are never repeated. Understanding the life of Dr. Héctor P. García allows us to exercise our rights for voting to elect responsible leaders, demanding adequate healthcare and protecting our veterans' sacrifices for our country.

That one phone call from my mother, Wanda, in March 2004 changed my life forever. It also gave me the determination to make certain that my father's legacy would never be forgotten for future generations.

EPILOGUE

The focus of *The Inspiring Life of Texan Héctor P. García* was to detail major events of my father's life that affected him and directed him to achieve the remarkable accomplishments that have made this a better country. The events I have written about were very significant, as not only did they change the course of history but they also channeled his efforts in a positive manner to accomplish what his vision was for this country: a better America that was free from segregation and had improved access to healthcare and higher education for minority students. The rights that are given in the United States Constitution belong to everyone, regardless of the color of their skin or their ethnicity.

We can learn from my father's passion, persistence and perseverance. A prime example of someone who never gave up, he certainly is a role model for our youth, the oppressed and disadvantaged. I think that his ability to succeed against all odds is certainly a lesson for all Americans. One cannot dismiss his efforts as short term, as he fought for more than fifty years to achieve positive outcomes.

He was able to live the American Dream, and he unselfishly wanted everyone else to achieve what he had accomplished. He recognized early in his life what his mission would be, and he skillfully incorporated everyone around him to join in his efforts.

As he was a very complex individual in so many areas, it was difficult for him to show his emotions, particularly closeness with his family, until much later in his life. We all knew that he loved us, though, and he would never

deny us anything we needed. He was always strict with his children, but we understood that he was always looking out for us and that he wanted us to achieve greatness and independence. I always wanted to be accepted in his eyes. I wanted him to feel that I had achieved greatness also. I realized much later that he was satisfied with my choices.

Having two very accomplished parents was difficult. A child always wants to excel, to feel her parents' pride and love for their efforts. But there was always that doubt about their acceptance of my own accomplishments. It would take years to feel that I had done my best and to feel comfortable with myself. Some people have told me, "It's going to be difficult filling your father's shoes." I am certain that I never wanted to fill his shoes, but I wanted everyone to know about him and recognize his contributions to this country. He deserved better historically than what people actually knew about him.

I will always honor and respect my mother, Wanda, for her tremendous sacrifices supporting my father. One cannot understand the pain and loneliness she felt for many years and, at times, the difficulty understanding his constant advocacy for others. She provided and lived a good life until the end, offering proper care and attention. His children would always defend their father; however, the name calling against him would produce much sadness, permanent scars and anxiety for us. We would all grow up and have our own lives and families yet never forget our past.

I feel that I have accomplished many things with my first book—not only detailing specific historical events but also including personal information about my father's life that no one else would have known. I wanted to add some humor, as he was a very engaging person and was much loved by everyone who knew him.

This was the life of Dr. Héctor P. García. A life filled with achievements, controversy, sacrifices, compassion and love. A life that we can all admire and emulate. His legacy is certainly multidimensional and applies to all of us as we live our own lives today. When things become difficult, I always look back at my father's life for strength and all the things he taught me. A father's love is forever. I always say to him, "*Papa, yo siempre te amaré*," which means in English, "I will always love you."

BIOGRAPHY, AWARDS AND HONORS FOR DR. HÉCTOR P. GARCÍA

D R. HÉCTOR P. GARCÍA, PHYSICIAN AND FOUNDER OF THE AMERICAN GI FORUM OF THE UNITED STATES OF AMERICA. Born in Mexico on January 17, 1914, the son of Mr. Jose García and Mrs. Faustina Perez García. Graduate of University of Texas with Bachelor of Arts degree, 1936; graduate of the University of Texas School of Medicine–Galveston, doctor of medicine, 1940. Married Wanda Fusillo on June 23, 1945. Children: Daisy, Héctor Jr., Adriana Cecilia and Susanna Patricia.

1940–41
General internship, St. Joseph's Hospital, Creighton University, Omaha, Nebraska.

1941–42
Surgical internship, St. Joseph's Hospital, Omaha, Nebraska.

1942–46
Service in World War II as an officer in the infantry, Engineer Corps and the Medical Corps. Completed military service at the rank of major in the Medical Corps in the European Theater of Operations. Awarded a Bronze Star Medal, the European/African/Middle Eastern Medal with 6 Bronze Stars and the World War II Victory Medal.

APPENDIX

MARCH 26, 1948
Founded the American GI Forum in Corpus Christi, Texas, as the first national chairman and founder.

1960
National coordinator and national organizer of the Viva Kennedy clubs.

1961
Representative of President John F. Kennedy and member of the American delegation signing treaty concerning Mutual Defense Area Agreement between the United States of America and the Federation of the West Indies.

MARCH 9, 1964
Appointed by President Lyndon B. Johnson as presidential representative with rank of special ambassador to the inauguration of Dr. Raúl Leoni, president of Venezuela.

FEBRUARY 14, 1967
Accompanied Vice President Hubert H. Humphrey and the U.S. delegation for the signing of the Treaty of Tlatelolco in Mexico City.

MARCH 4, 1967
Appointed by President Lyndon B. Johnson as member of the National Advisory Council on Economic Opportunity of the United States.

SEPTEMBER 1967
Appointed by President Lyndon B. Johnson as alternate representative to the United Nations from the United States with the rank of ambassador.

NOVEMBER 1968
Sworn in as a commissioner of the United States Commission on Civil Rights.

MAY 1969
Presented the Humanitarian Award by the Corpus Christi Chapter of the NAACP.

FEBRUARY 1972
Named member of the Texas Advisory Committee to the United States Commission on Civil Rights.

MAY 1977
Appointed by President Jimmy Carter as member of the U.S. Circuit Court Judge Nominating Commission for the Western Fifth Circuit Panel.

APPENDIX

JANUARY 9, 1980
Attended President Jimmy Carter's high-level briefing at the White House in reference to Iran, Afghanistan and Pakistan crisis.

MARCH 26, 1984
Awarded the Presidential Medal of Freedom by President Ronald Reagan at the White House.

FEBRUARY 19, 1985
Honored with naming of the Dr. Héctor P. García Endowed Chair, Yale University's Chicano Research Center, New Haven, Connecticut.

SEPTEMBER 14, 1988
Honored by the U.S. Postal Service with the renaming of the Main Post Office in Corpus Christi, Texas.

SEPTEMBER 12, 1989
Presented the Hispanic Heritage Award by the National Hispanic Leadership Conference, Washington, D.C.

OCTOBER 6, 1989
Presented the Distinguished Alumnus Award from the University of Texas Ex-Students Association.

MAY 17, 1990
Presented the Equestrian Order of Pope Gregory the Great from Pope John Paul II.

APRIL 1990
Designated Corpus Christi State University as the institution to house Dr. Héctor García's papers in the Special Collections and Archives Department of the Library.

MAY 10, 1991
Received Corpus Christi State University's first Honorary Doctorate of Humane Letters degree, given by CCSU president Dr. Robert Furgason.

JUNE 1996
Dr. Héctor P. García Plaza and statue were dedicated at Corpus Christi State University.

APPENDIX

1997
Héctor P. García Elementary School in Grand Prairie, Texas, is dedicated and opened.

August 7, 1998
Posthumously awarded the Águila Azteca Award from the government of Mexico.

1998
Héctor P. García Elementary School in Temple, Texas, is dedicated and opened.

1999
Image is placed on the U.S. Treasury's seventy-five-dollar I-Bond series honoring great Americans.

2002
Public television station KEDT in Corpus Christi, Texas, produces a documentary on Dr. Héctor García entitled *Justice for My People: The Dr. Héctor P. García Story*. The program was broadcast nationally on PBS.

2007
Héctor P. García Middle School in Dallas, Texas, is dedicated and opened.

December 18, 2007
Information read into Congressional Record, 110th Congress, Senate, honoring "The Life and Accomplishments of Dr. Héctor P. García," by John Cornyn and Kay Bailey Hutchison.

2008
Major Héctor P. García, MD, High School in Chicago, Illinois, is dedicated and opened.

April 2008
Texas Highway 286 is named the Dr. Héctor P. García Memorial Highway.

May 30, 2009
Texas governor Rick Perry signs SB495, establishing a State Recognition Day to be observed on the third Wednesday of each September.

October 2009
Dr. Héctor P. García Middle School in San Antonio, Texas, is dedicated and opened.

APPENDIX

APRIL 2010
United States House of Representatives passes H.CON.RES.222, recognizing the leadership and historical contributions of Dr. Héctor P. García.

JANUARY 2012
Bronze bust of Dr. Héctor García is dedicated at the Dr. Héctor P. García Public Library, Mercedes, Texas.

2013
Texas Historical Marker is unveiled at Dr. Héctor P. García Public Library, Mercedes, Texas.

JANUARY 17, 2014
Dr. Héctor P. García's official 100th Birthday Celebration is observed in Corpus Christi, Texas, by the Dr. Héctor P. García Memorial Foundation.

FEBRUARY 2014
Texas Historical Marker is unveiled at Christus Spohn Memorial Hospital, Corpus Christi, Texas.

SEPTEMBER 2014
Dr. Héctor P. García Memorial Family Health Center is approved by Nueces County commissioners and Hospital District, to be opened in 2016.

JANUARY 13, 2015
Braselton Homes unveils street named Dr. Héctor P. García Drive in Rancho Vista, Corpus Christi, Texas.

NOTES

FOREWORD

1. Carroll, *Felix Longoria's Wake*, 1–3.

CHAPTER 1

2. García, *Héctor P. García*, 1–9.
3. Dr. Héctor P. García, correspondence to Headquarters First Military Area, Office of the Executive, Federal Building, December 16, 1941, Héctor P. García Papers, Bell Library, Texas A&M University–Corpus Christi.

CHAPTER 2

4. García, *Héctor P. García*, 51.
5. Captain W.M. Dunham, correspondence to Second Lieutenant Héctor P. García, 357th Infantry, Camp Bullis, Texas, August 12, 1935, Héctor P. García Papers.
6. Major C.C. Patterson, correspondence to Colonel Sylvan Lang, Commanding Officer, 357th Infantry, San Antonio, Texas, August 12, 1939, Héctor P. García Papers.

7. Dr. Héctor P. García, correspondence to Headquarters First Military Area, 357th Infantry, December 16, 1941, Héctor P. García Papers.
8. Dr. Héctor P. García, correspondence to U.S. Army, March 18, 1942, Héctor P. García Papers.
9. U.S. Army telegram to First Lieutenant Héctor Perez García, St. Joseph's Hospital, Omaha, Nebraska, June 15, 1942, Héctor P. García Papers.
10. Colonel William F. Weller, CE, correspondence to Commanding General, Seventh Army, U.S. Army, proposed citation, May 31, 1945, Héctor P. García Papers.
11. U.S. Army, Certificate of Service, separation papers, March 1, 1946, Héctor P. García Papers.
12. U.S. citizenship document, November 7, 1946, Héctor P. García Papers.

Chapter 3

13. Telephone interview with Tony Canales by Cecilia García Akers, October 22, 2015.
14. Diocese of Corpus Christi, Texas website, "Bishop Mariano S. Garriga," diosesecc.org/Bishop-Mariano-S-Garriga.
15. Carroll, *Felix Longoria's Wake*, 55–63.
16. Ibid., 66.
17. *Hernandez v. State of Texas*, 347 U.S. 475, Texas State Historical Association, May 3, 1954.
18. *Brown v. Board of Education of Topeka, Kansas*, 347 U.S. 483, Supreme Court of the United States, May 17, 1954.
19. *Cisneros v. Corpus Christi Independent School District*, Civ. No. 68-C-95, Texas State Historical Association, July 2, 1971.

Chapter 4

20. *The Tiger*, Mercedes High School, Mercedes, Texas, March 3, 1931.
21. Ibid., May 27, 1932.
22. Personal letters to Héctor García Jr. from Wanda F. García and Cecilia García, June, 1962.
23. Letter of acceptance for Héctor García Jr. from Corpus Christi Academy, May 18, 1962, author's personal collection.

CHAPTER 6

24. Commission to the United Nations to Héctor P. García of Texas by President Lyndon B. Johnson, September 22, 1967, Héctor P. García Papers.
25. Secretary of State Dean Rusk, letter to Héctor P. García, October 11, 1967, Héctor P. García Papers.
26. United Nations Certificate of Appreciation to Ambassador Héctor P. García, MD, December 10, 1967, Héctor P. García Papers.

CHAPTER 7

27. Chronology of Corpus Christi Independent School District sequence of events, 1954–71, Héctor P. García Papers.
28. Department of Health, Education and Welfare, letter to Superintendent Dana Williams, October 21, 1968, Héctor P. García Papers.
29. United States District Court, Southern District of Texas, Corpus Christi Division, judgment by Judge Woodrow Seals, C.A. No. 68-C-95, June 4, 1970, Héctor P. García Papers.
30. Dr. Héctor P. García, press release, August 29, 1970, Héctor P. García Papers.
31. *Cisneros v. Corpus Christi Independent School District*, Texas State Historical Association, Handbook of Texas Online, June 12, 2010.

CHAPTER 8

32. New World Encyclopedia, "Presidential Medal of Freedom," May 28, 2015, http://www.newworldencyclopedia.org/entry/Presidential_Medal_of_Freedom.

CHAPTER 10

33. Fusillo, "Virgil's Aeneid, Book II"; doctoral thesis and diploma in humane letters, Wanda Fusillo, University of Naples, June 24, 1944.
34. Héctor P. García citizenship papers, November 7, 1946, Héctor P. García Papers.

SELECTED BIBLIOGRAPHY

Carroll, Patrick J. *Felix Longoria's Wake*. Austin: University of Texas Press, 2003.

Diocese of Corpus Christi, Texas. www.diocesecc.org/Bishop-Mariano-S-Garriga.

Fusillo, Wanda. "Virgil's Aeneid Book II." doctoral dissertation, University of Naples, 1944.

García, Ignacio M. *Héctor P. García: In Relentless Pursuit of Justice*. Houston, TX: Arte Publico Press, University of Houston, 2002.

Héctor P. García Papers. Bell Library, Texas A&M University, Corpus Christi, donated 1990.

Justice for My People: The Dr. Héctor P. García Story. PBS Documentary, 2002.

Mercedes High School. *The Tiger*. Mercedes, Texas, 1931–32.

New World Encyclopedia Contributors. www.newworldencyclopedia.org.

Texas State Historical Association. www.tshaonline.org.

INDEX

ABOUT THE AUTHOR

Cecilia García Akers is the middle daughter of Dr. Héctor P. and Wanda F. García. She was born and raised in Corpus Christi, Texas, and graduated from Incarnate Word Academy. She is a graduate of St. Mary's University in San Antonio, Texas, with a bachelor's degree in biology and a graduate of the University of Texas Medical Branch–Galveston with a degree in physical therapy. She has extensive clinical experience in physical therapy and is currently practicing in geriatric orthopedics and neuromuscular

Cecilia García Akers, founding president/ chairman of the Dr. Héctor P. García Memorial Foundation, June 2012. *Incarnate Word Academy.*

rehabilitation. Cecilia is the founding member of the Dr. Héctor P. García Memorial Foundation and serves as its board president/chairman. She has written editorials for the *Corpus Christi Caller Times* and the *Waco Tribune* regarding the legacy of her father, Dr. Héctor P. García. Cecilia is married to Jimmy Akers and resides in San Antonio, Texas.